Point of View New York City

A Visual Game of the City You Think You Know

Janko Puls

CN
TIMES BOOKS

PERMISSIONS

1: The Solomon R. Guggenheim Museum, New York. ©SRGF, NY

13: ©2014 Frank Stella/Artists Rights Society (ARS), New York

13 & 87: Courtesy of the Metropolitan Museum of Art

42: John Barnard, Ferrari S.p.A., Maranello, Italy (established 1929). Formula 1 Racing Car (641/2). 1990. Courtesy of the Museum of Modern Art, NY.

56: Courtesy of the Smithsonian's National Museum of the American Indian

100 & 107: Courtesy of the American Museum of Natural History

Text design and composition by India Amos

Map design by Minna Ninova

Author photo by Bo Zaunders

BEIJING MEDIATIME BOOKS CO., LTD.

CN Times Books, Inc.

501 Fifth Avenue

New York, NY 10017

cntimesbooks.com

ORDERING INFORMATION

Quantity sales. Special discounts are available on quantity purchases by corporations, associations, and others. For details, contact the publisher at the address above.

Orders by US trade bookstores and wholesalers: Please contact Ingram Publisher Services: Tel: (866) 400-5351; Fax: (800) 838-1149; or customer.service@ingrampublisherservices.com.

ISBN-13: 978-162774-088-3

ISBN-10: 1-62774-088-0

Printed in China

Contents

vii Introduction

1 View

146 Points

147 Maps

149 Index

176 Acknowledgments

177 About the Author

Introduction

When I moved to New York as a journalist in 2006, I set out right away to explore my new home, workplace, and playground. Mapping my personal city in photos and stories gave me a way to solidify my impressions and share them with readers, friends, and family. I was excited to place the quintessential architecture and famous parks in context, and to learn the lay of the city I thought I knew so well from TV, movies, and literature.

But something surprised me. Whenever I walked the streets with my wife, a born-and-raised Manhattanite, she would say, "This used to be here, that used to be there." I sometimes found that vexing, since I wanted to discover today's city, not one from the past. But she was right, New York was disappearing: a moment came when I knew more vanished places than actually existing ones. Luckily, greedy real estate developers replenished quickly what was left of our fair city—at times with something better, often with something worse. Within a few months, I was singing along with my wife's lamentations. It was when I noticed that, I suppose, that I really became a New Yorker.

Berenice Abbott masterfully captured the essence of the ever-molting city in her 1939 photo book *Changing New York*. She may have chronicled one of the most active periods of the city's transformation, but New York's permanent self-renewal continues at an incredible pace. As O. Henry quipped several decades before Abbott's book, "It'll be a great place if they ever finish it." Hopefully, they never will.

The photographs in this book were taken between 2008 and 2014. But New York is an ever changing place, which means that some of the locales here might appear different today. My approach, in short, is to try to catch the essence of a place or situation, to let things speak for themselves. An architectural detail, for example, can tell so much about the spirit in which a building was planned, the intentions, and the attitude. Sometimes I circle my object for months before I connect; at other times I see it all come together in a snap. There is no staging; I prefer available light. But this isn't photojournalism or documentary photography. Through these images, I see and absorb, interpret and translate, and eventually create and map my very own city. Energy, diversity, beauty, craziness, and sheer size lured me in like millions before me. John Steinbeck explains it best:

> New York is an ugly city, a dirty city. Its climate is a scandal, its politics are used to frighten children, its traffic is madness, its competition is murderous. But there is one thing about it— once you have lived in New York and it has become your home, no place else is good enough.*

On one level, then, this book is my personal map of the city, highlighting some of the sights I find meaningful and noteworthy. I chose not to create yet another city guide, nor to cover the complete urbanscape, but to share with you my New York.

It's All About the Game

I would like to take you on a trip through the five boroughs, over a time span from 1524 to 2014. Don't worry, it won't take long, and it's not a history lesson, either. Instead, I have made it into a game.

The fact that cities, wherever they are, change over time is what makes them such interesting places. But in "the city so nice they named it twice"— New York, NY—clocks seem to tick a bit faster than they do elsewhere, and the resulting speed of change makes it really exciting. Because it appears so often on the screen and in books everybody knows New York, more or less; yet even if you live here, this ongoing change means nobody will ever know everything about it. But for what I have in mind, venerated reader, it doesn't matter whether you live here now or have never visited before. That you love this place is obvious by the fact that you are looking at this book. My challenge to you is: Do you really know this city you *think* you know? In your time here, have you ever stumbled upon wild parrots or a space rocket, marching elephants or an Egyptian obelisk, a Lenin statue or Peter Stuyvesant's peg leg? Here is a proposal: Let's play a game and see how many of the locations you can guess. Nearly all of the subjects are well known, but when I put this book together, I decided not to go the obvious route. Instead, I have included photos taken from unusual angles, or ones that give you just a hint about the location through an easily overlooked detail.

The last thing I want is to frustrate you, so if you really can't nail down a location in a photo, just look it up on the map or use the index, which gives you the address and beckons with some tidbit about the location that you may not have known. Just don't spoil the fun for yourself by giving up too quickly. If you want to see these places yourself, grab the map and start walking. I chose to include only photos from locations that are publicly accessible at no cost. No heroic efforts were necessary to take these images, only a few of which are of interiors. Some sites are easy to locate, even for a visitor, while others are likely to challenge even the most sharp-eyed denizen. In any case, you will have fun with this book, and you may just learn something new along the way.

I'm hoping, in fact, that solving these visual conundrums will inspire you to explore the city in more depth, and in your own fashion. Use the map in the back to put together your own itinerary, whether it's populated by photos, drawings, music, or words. Create your own map of this wonderful city. I'll continue to draw mine as I walk the streets with my wife in a state of belonging and constant discovery.

* John Steinbeck, "Autobiography: Making of a New Yorker," *New York Times Magazine*, 102 (1 Feb 1953): 26–27, 66–67.

VIEW

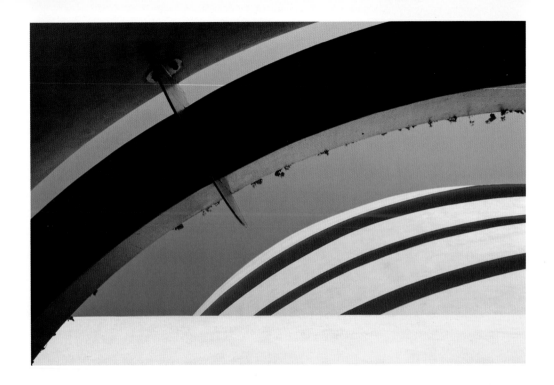

3

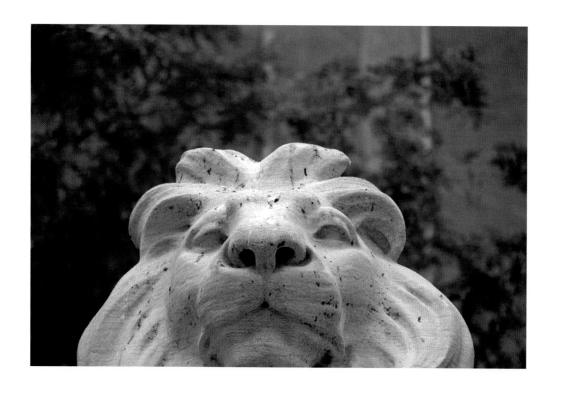

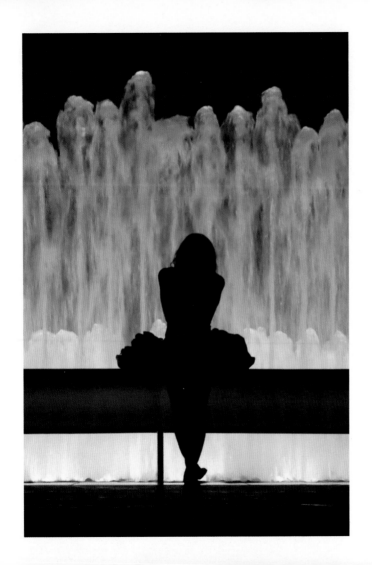

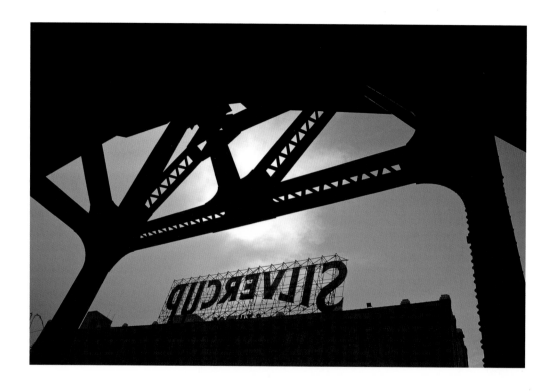

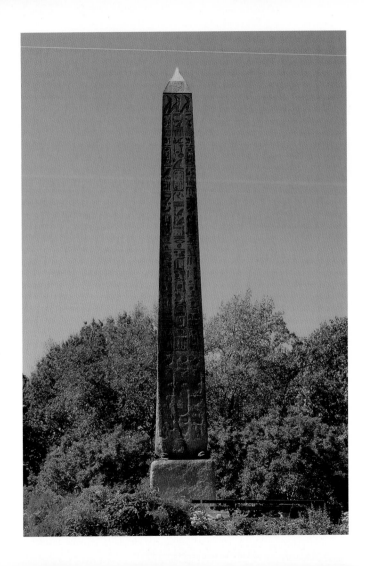

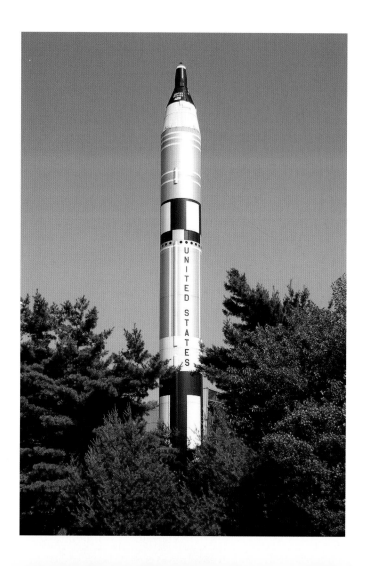

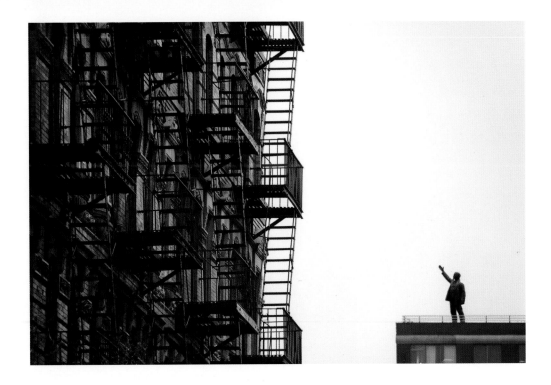

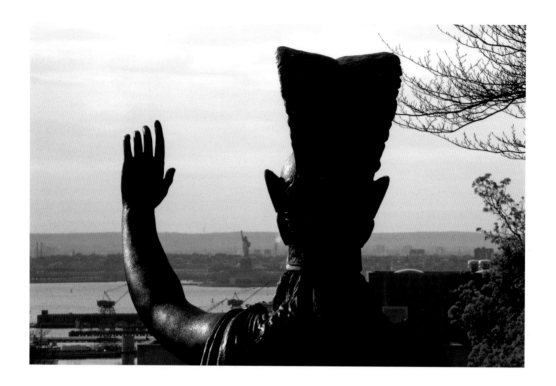

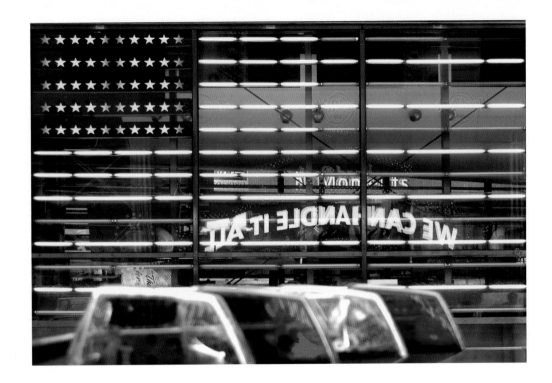

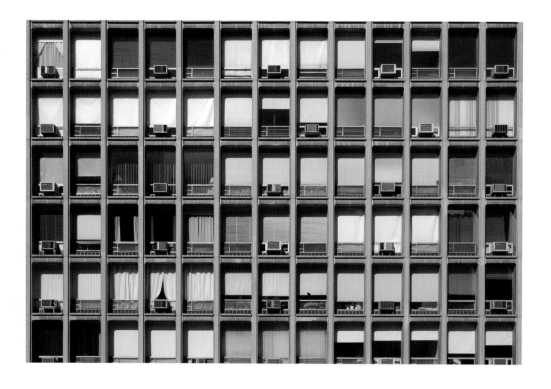

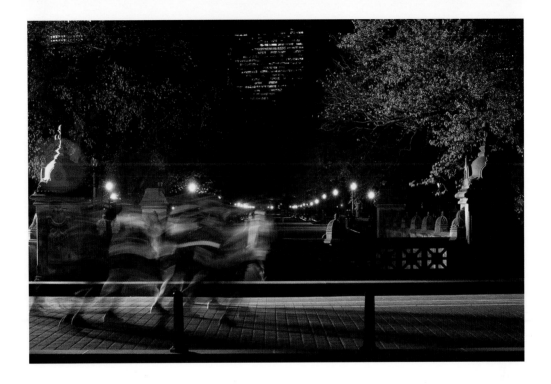

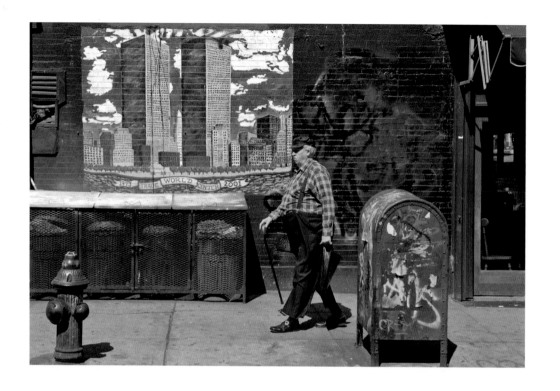

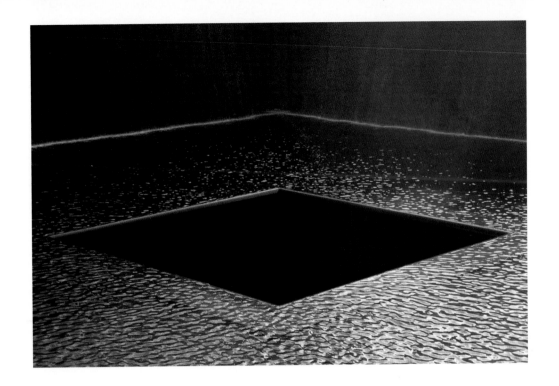

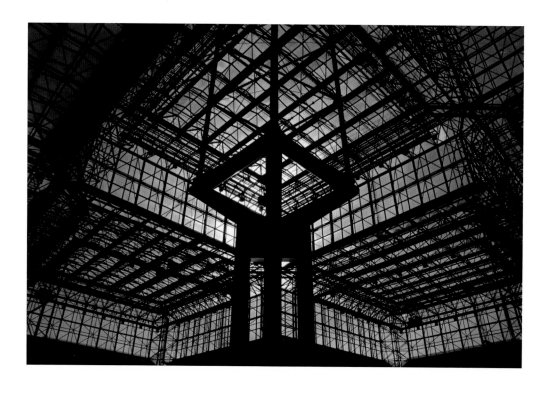

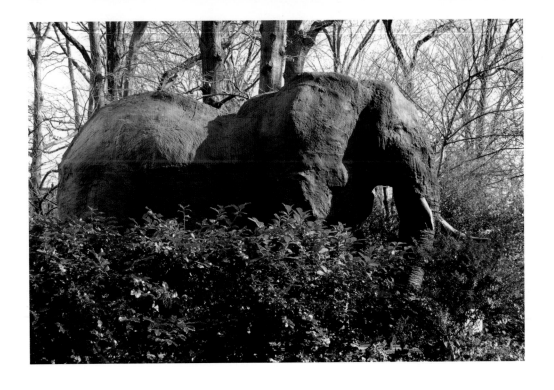

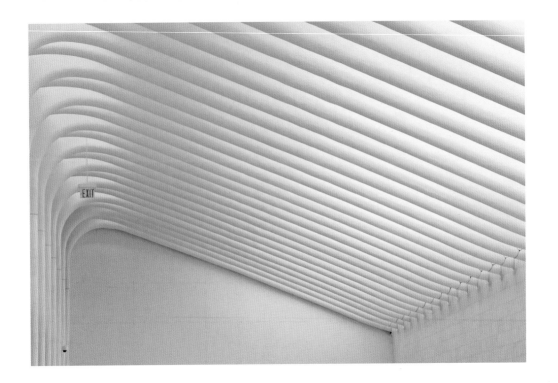

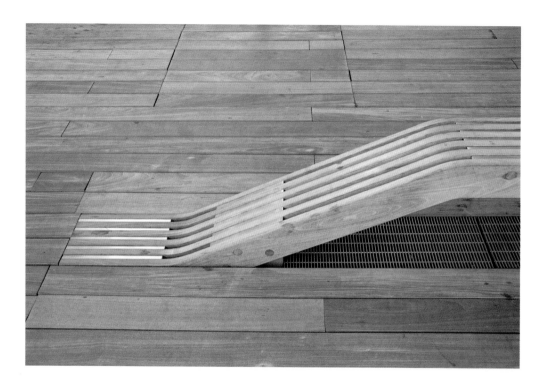

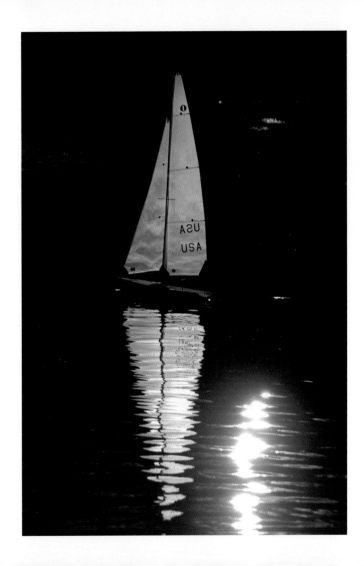

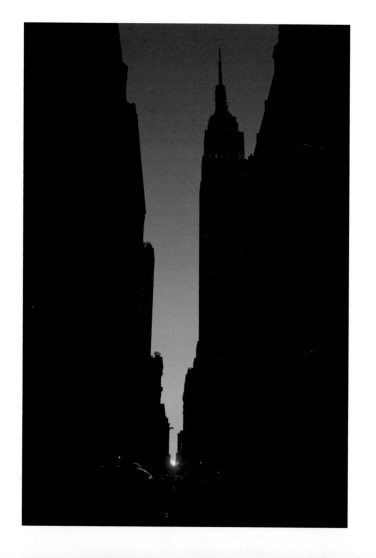

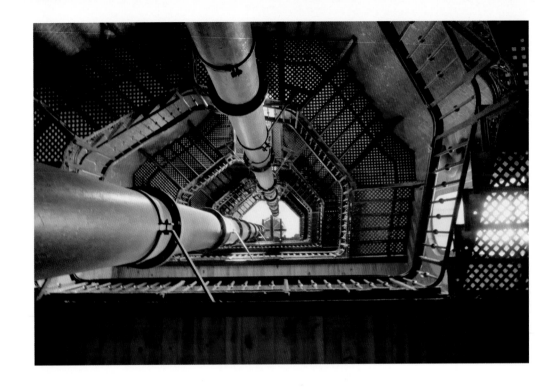

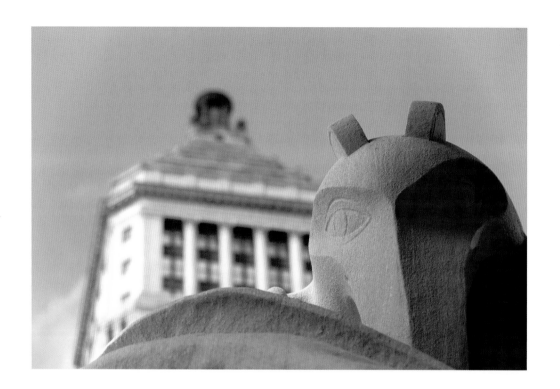

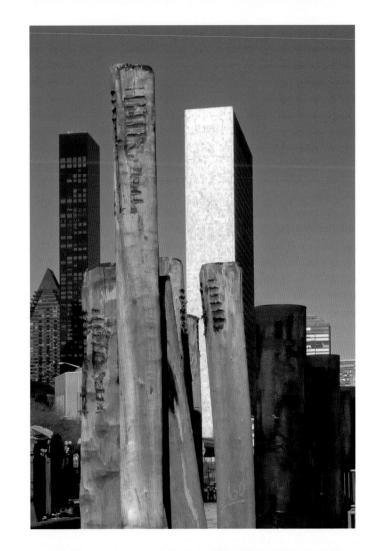

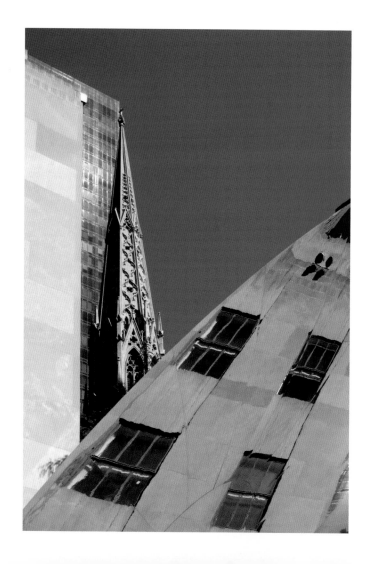

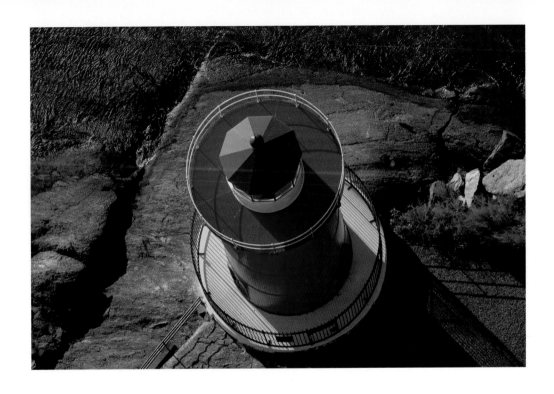

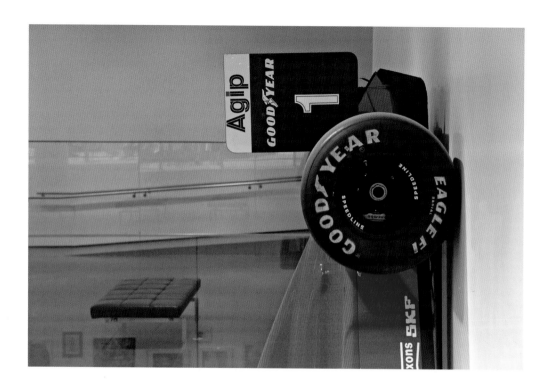

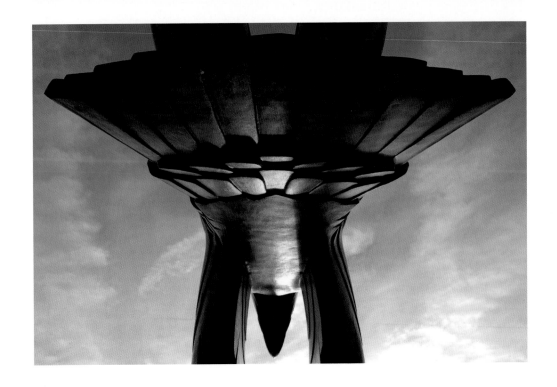

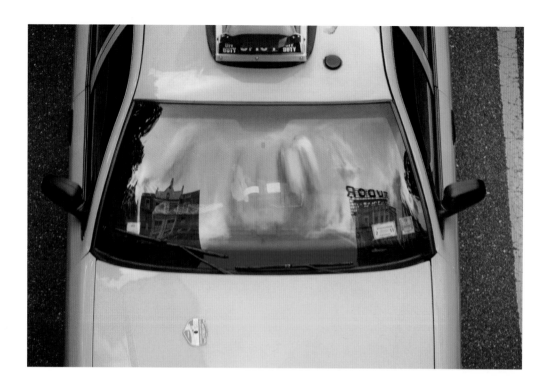

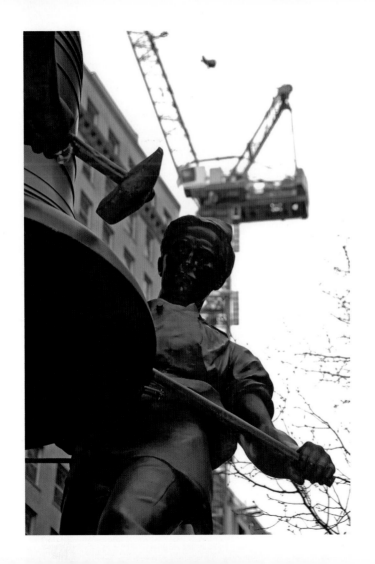

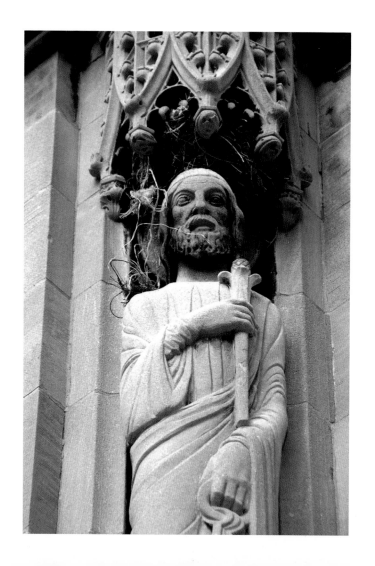

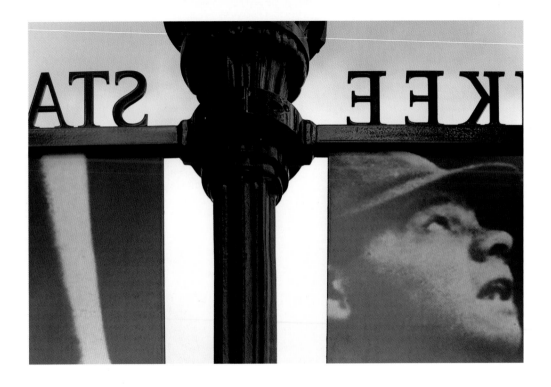

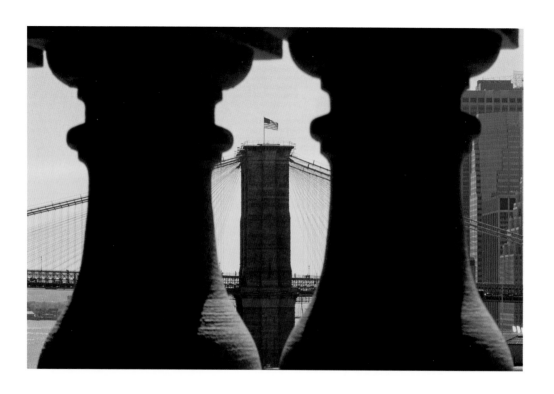

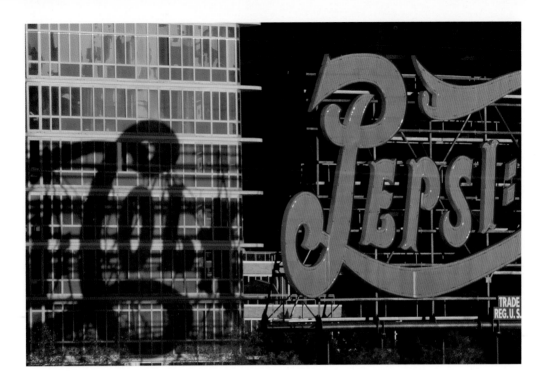

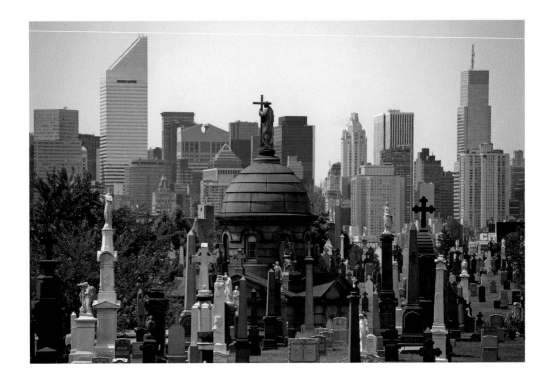

"We found a pleasant place below steep little hills. And from among those hills a mighty deep-mouthed river ran into the sea."

Giovanni da Verrazano, Italian explorer, 1524

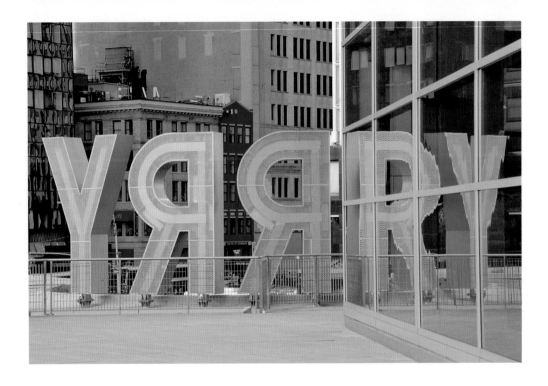

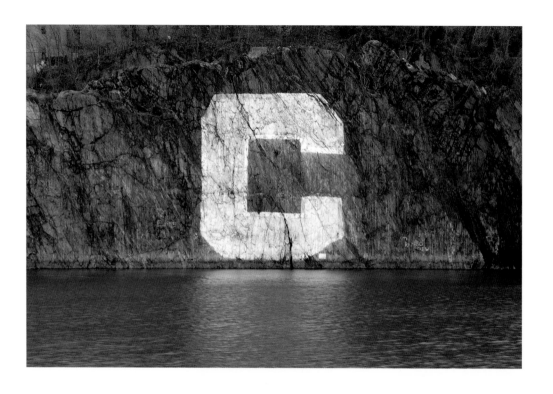

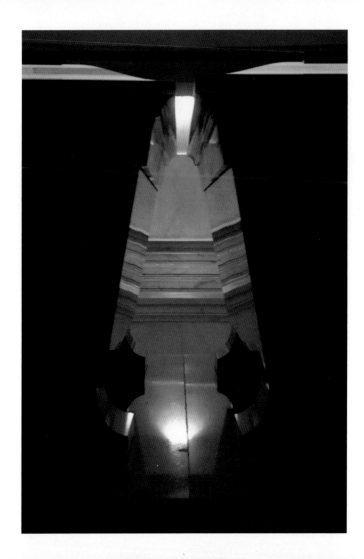

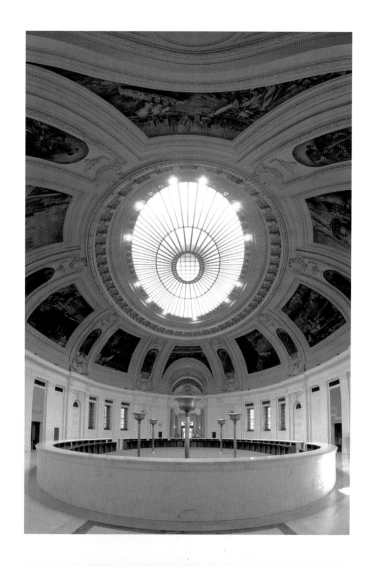

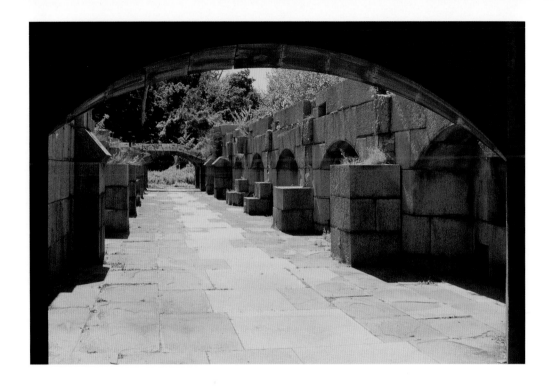

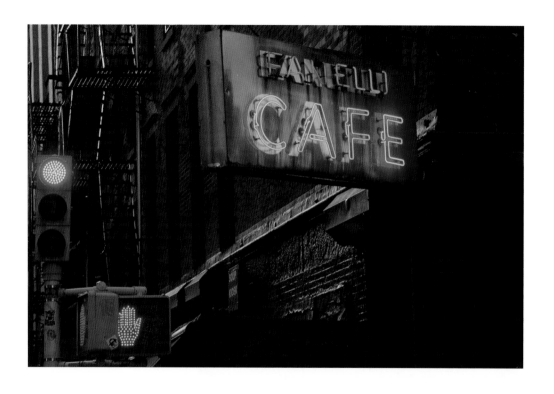

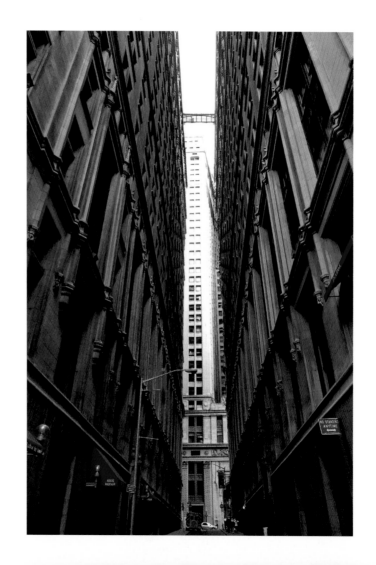

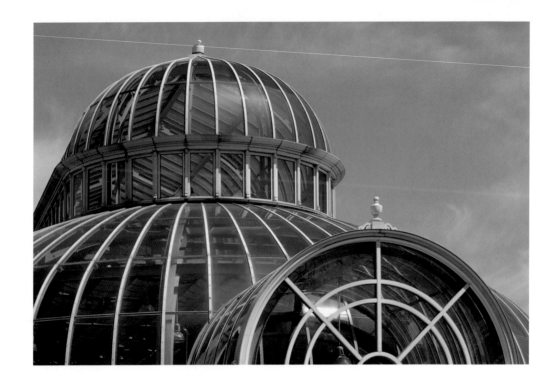

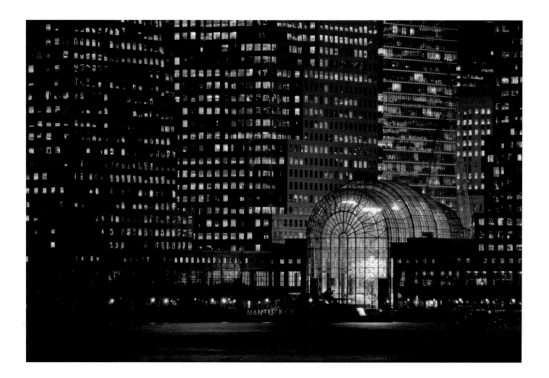

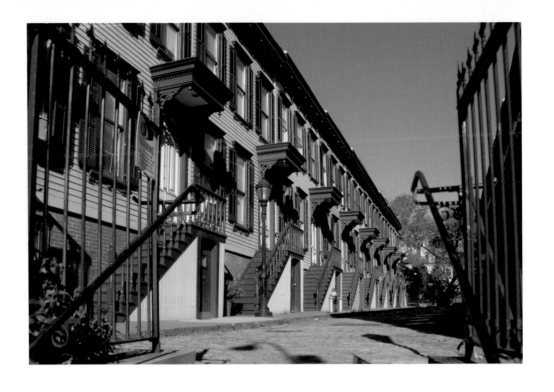

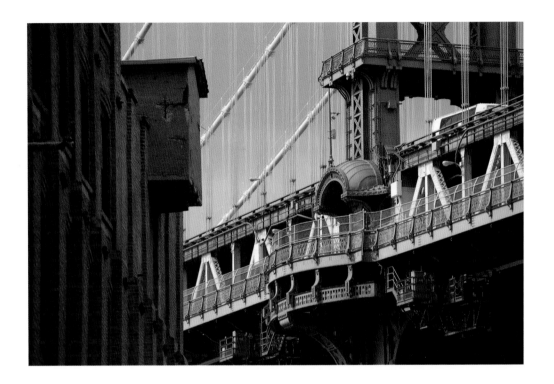

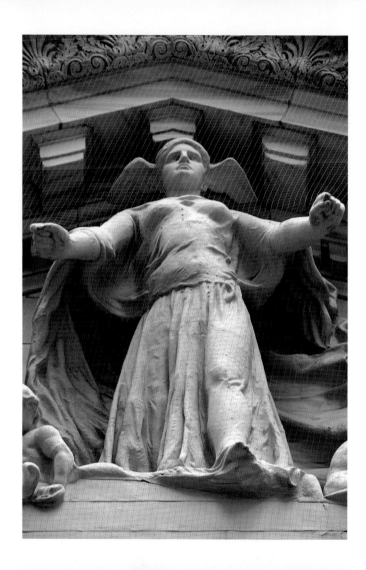

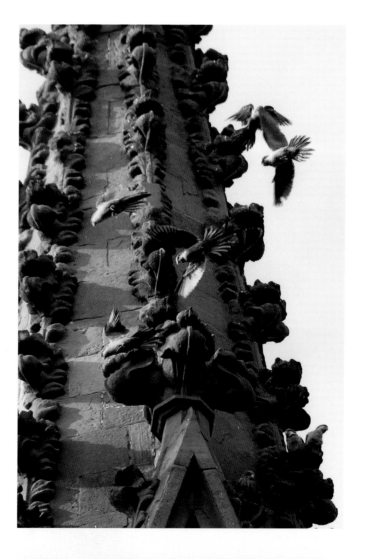

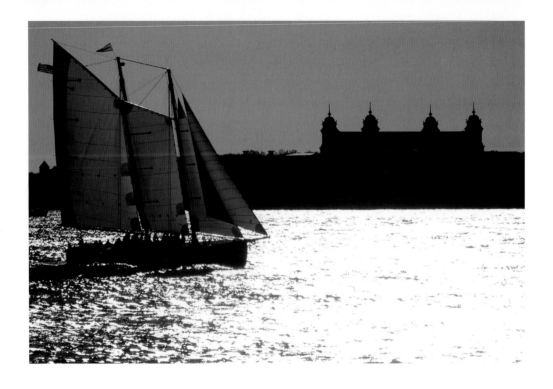

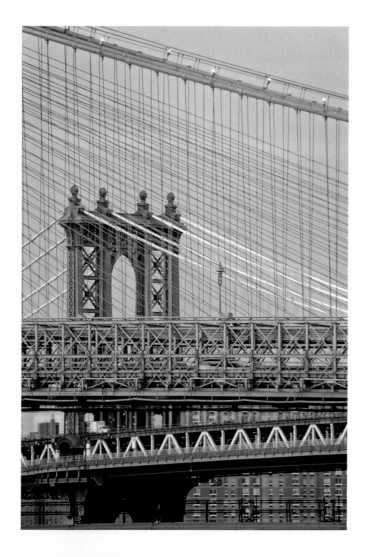

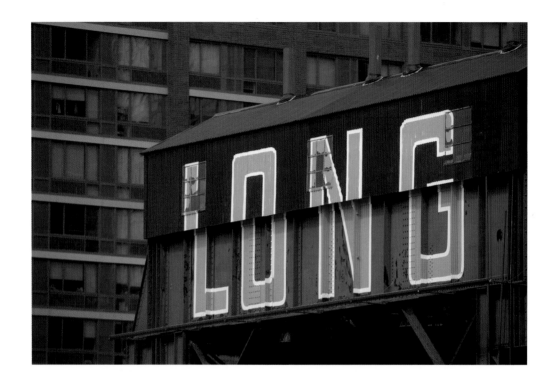

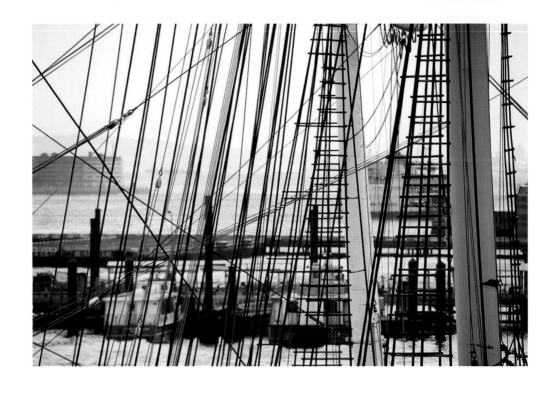

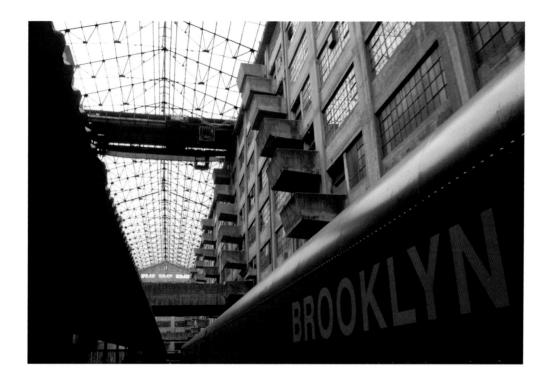

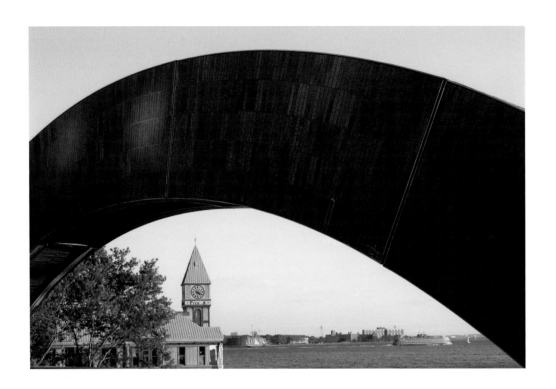

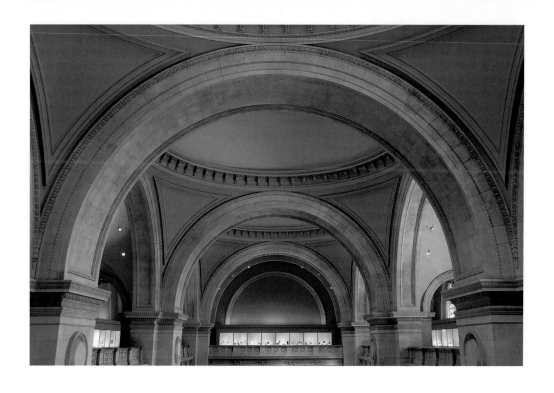

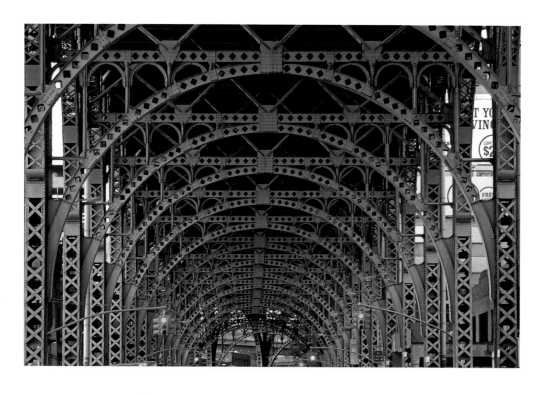

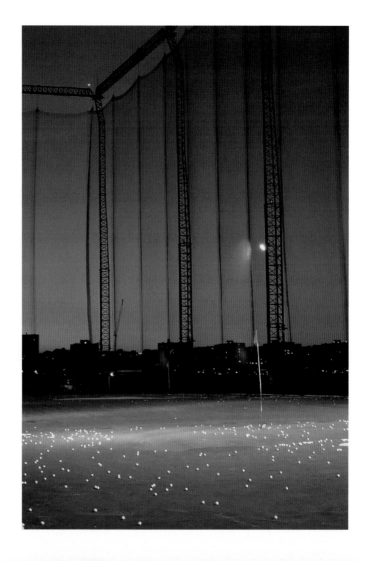

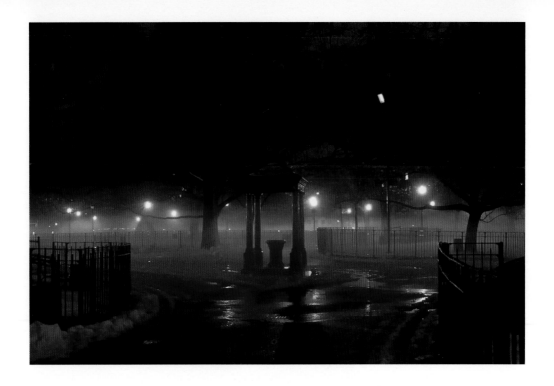

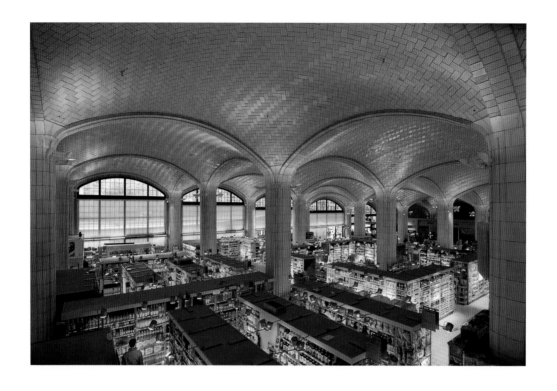

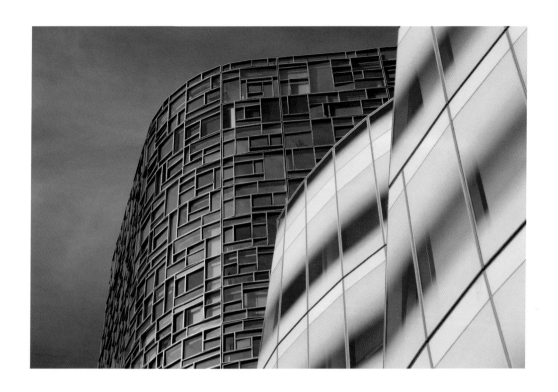

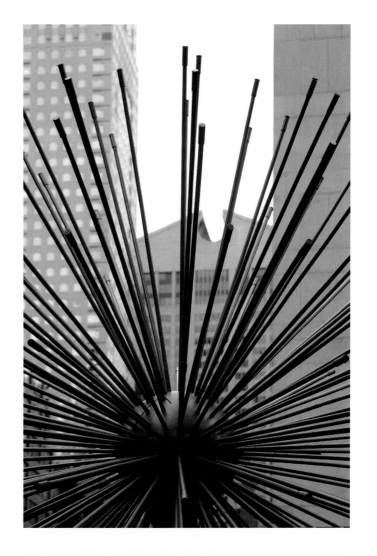

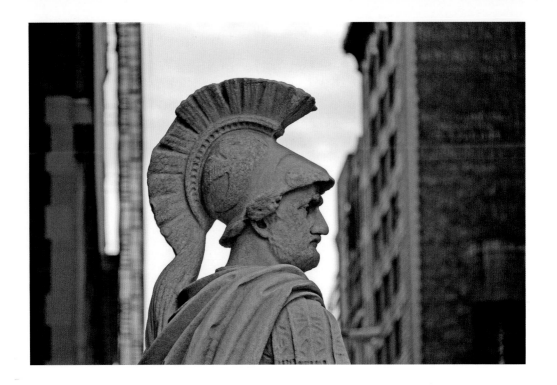

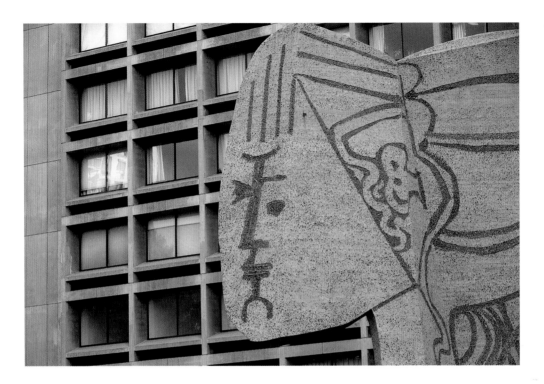

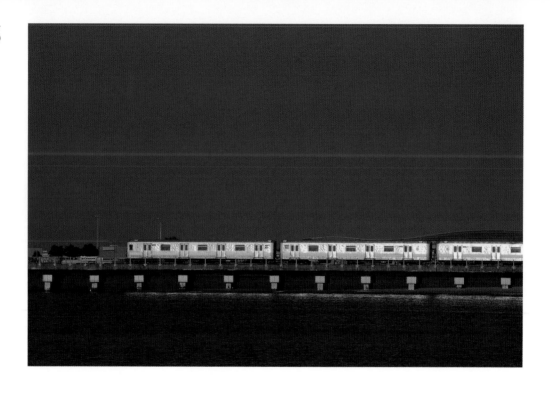

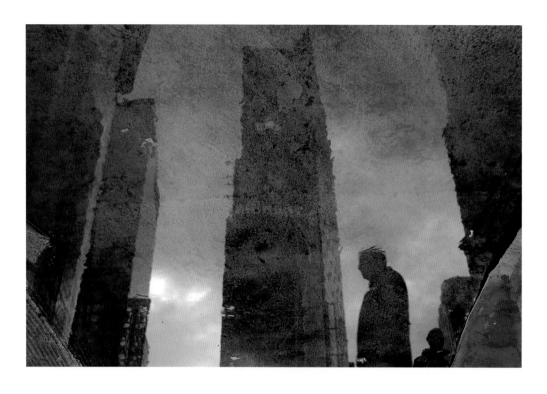

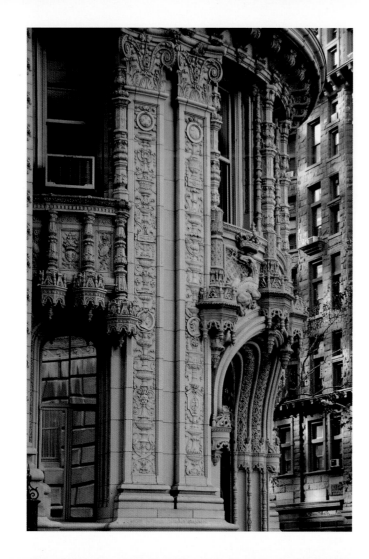

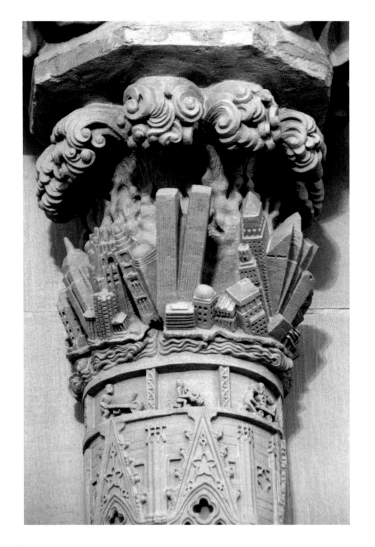

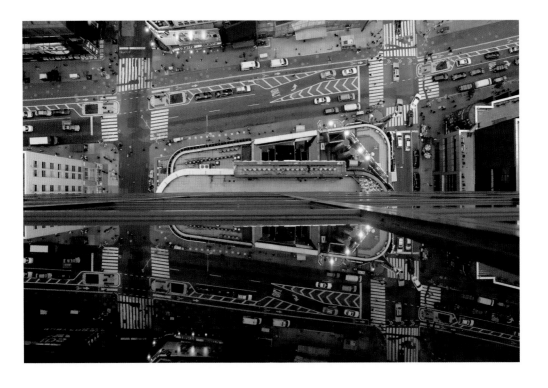

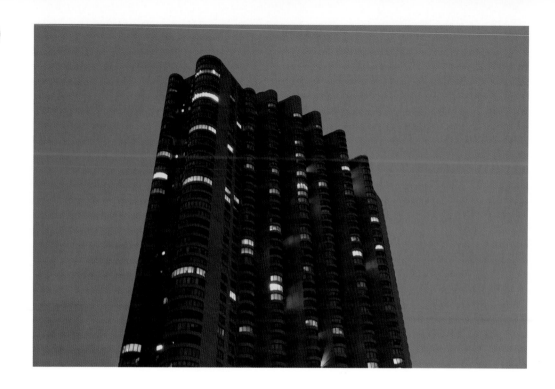

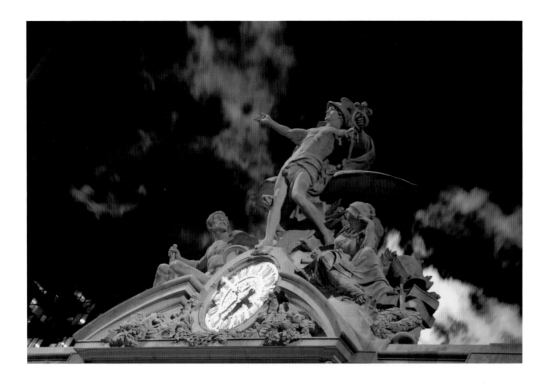

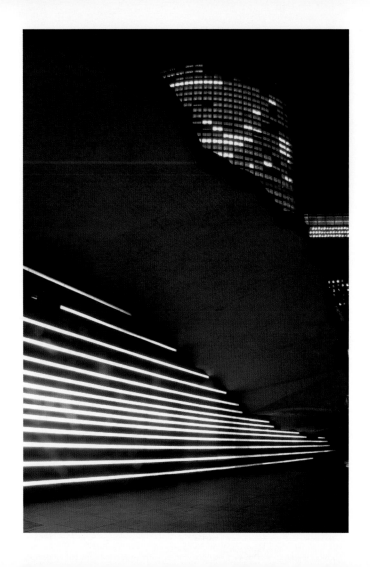

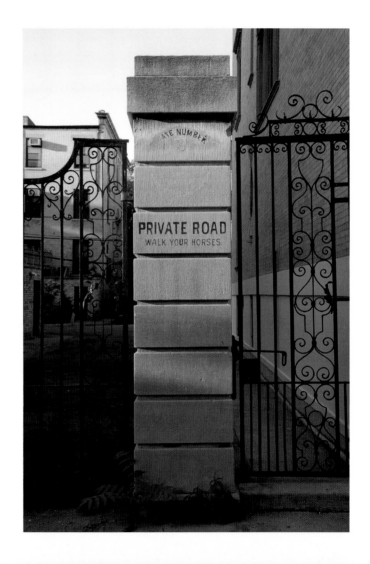

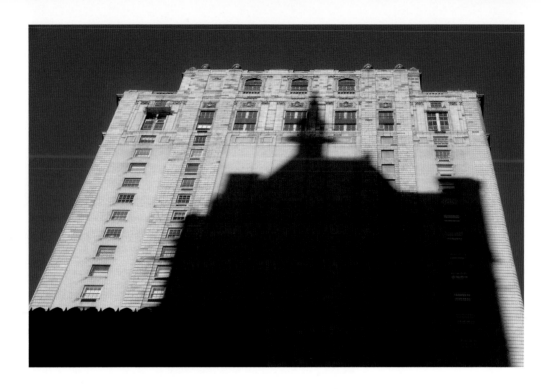

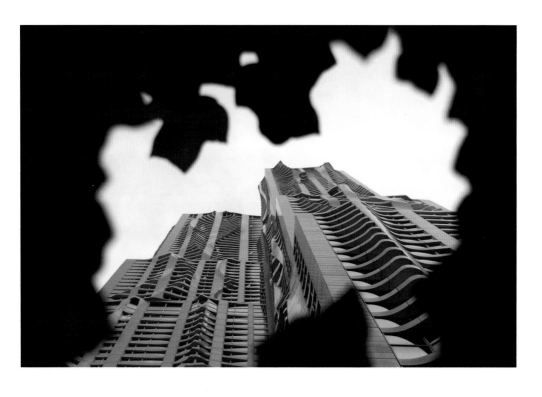

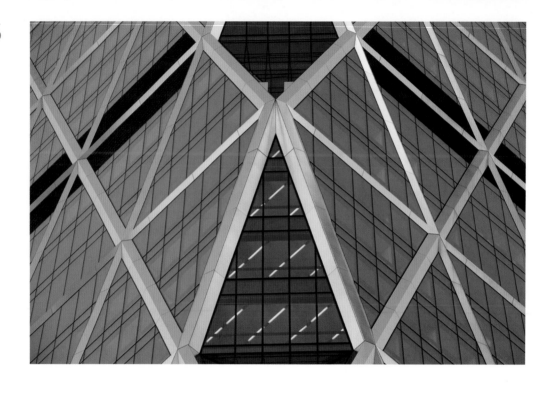

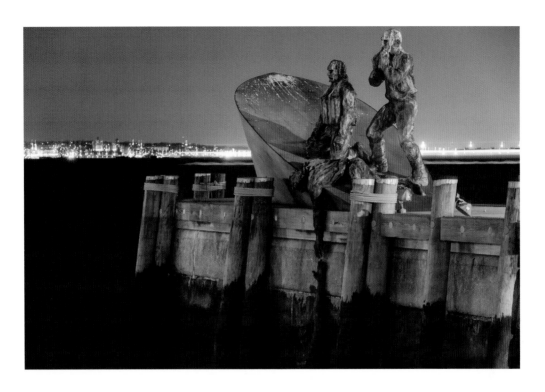

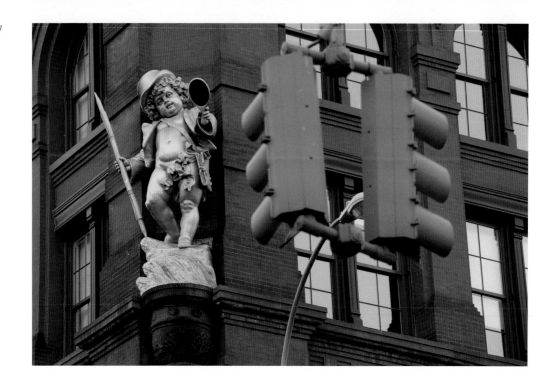

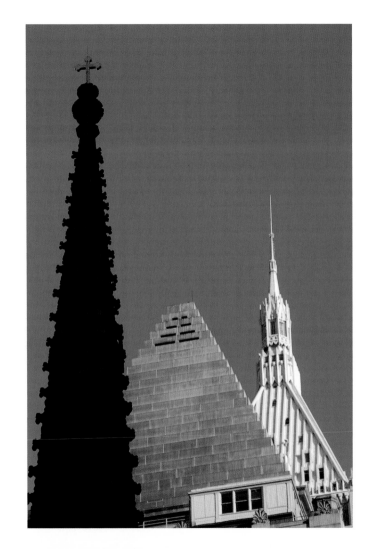

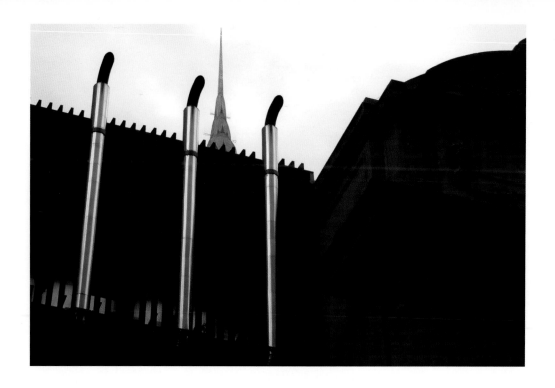

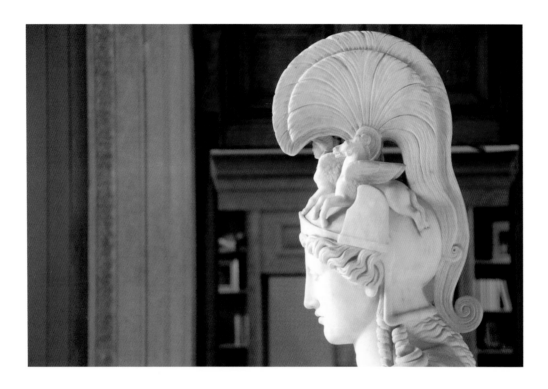

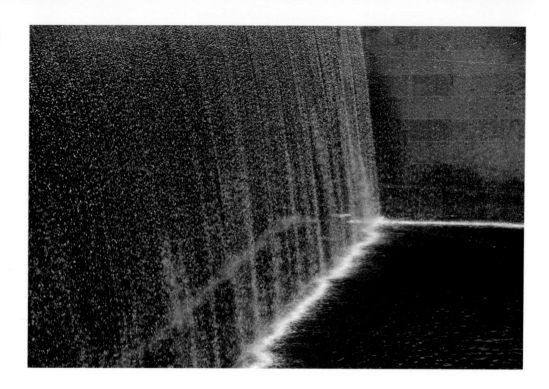

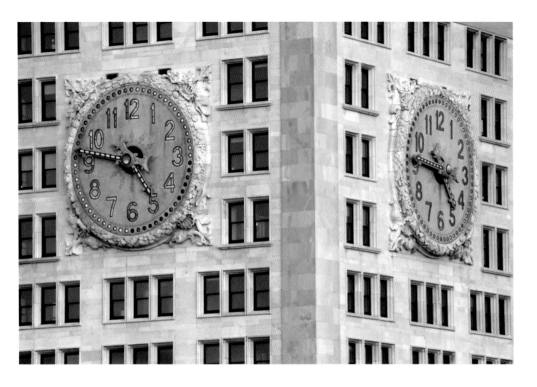

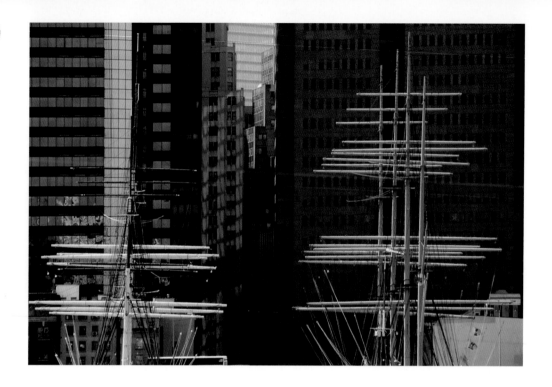

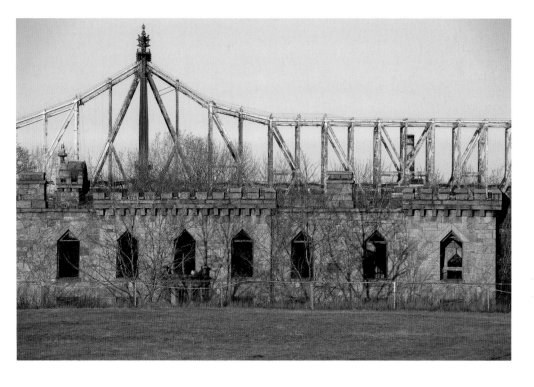

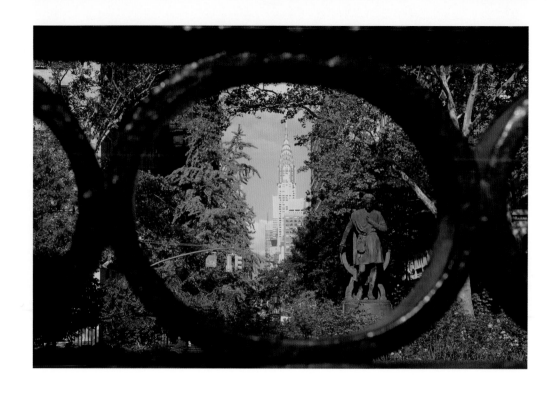

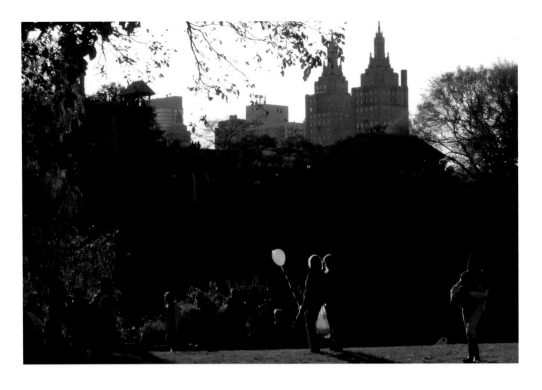

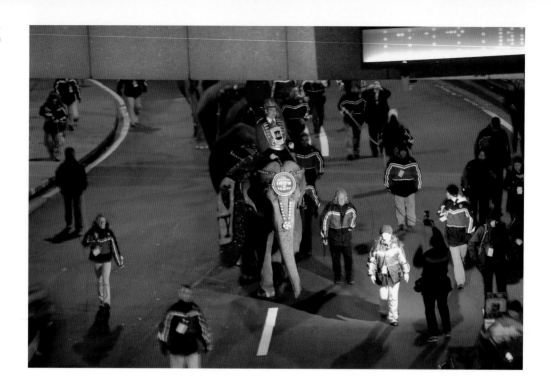

POINTS

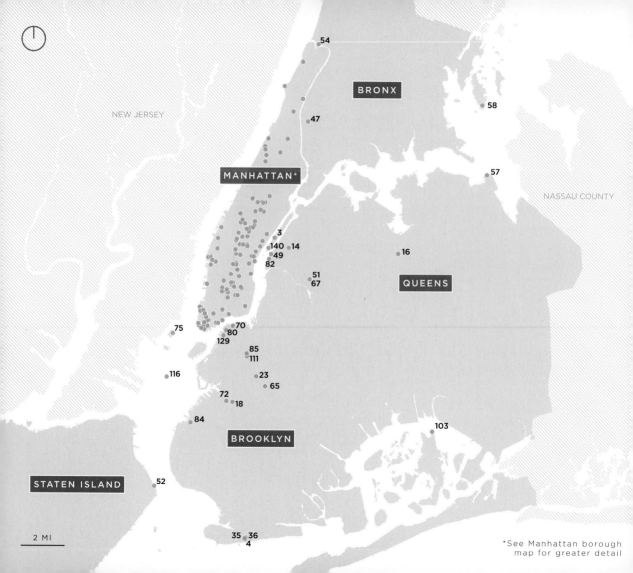

NEW JERSEY

BRONX

54

58

47

MANHATTAN*

57

NASSAU COUNTY

3
140 14
49
82

16

51
67

QUEENS

75

70
80
129

85
111

116

23
65

72
18

84

BROOKLYN

103

STATEN ISLAND

52

35 36
4

2 MI

*See Manhattan borough
map for greater detail

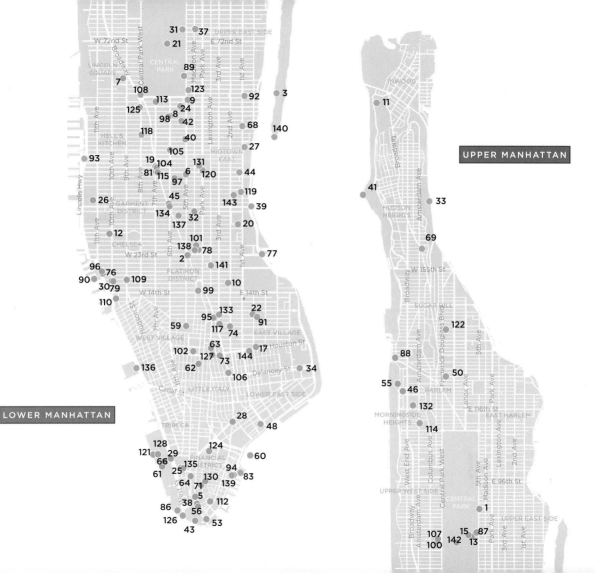

LOWER MANHATTAN

UPPER MANHATTAN

This index helps to locate the images in the book. Street addresses help you find the sites, and most can be used with a GPS navigation device. In most cases, the markers on the preceding map show the same addresses. Sometimes, though, it makes more sense to use a marker to indicate the exact position of an object within a larger area such as a park, cemetery or building complex. The map marker may also indicate the point of view from which a photo was taken, for example when the image was taken with a long telephoto lens.

1 SOLOMON R. GUGGENHEIM MUSEUM ▪ **1071 5th Ave, bet 88th & 89th Sts (Museum Mile / Upper East Side, Manhattan)** ▪ This world-famous museum is wider at the top than at the bottom. It opened in 1959, 10 years after the death of its founder, Solomon R. Guggenheim, and six months after the death of its famed architect, Frank Lloyd Wright Jr. Parks Commissioner Robert Moses likened it to "an inverted oatmeal dish," while Wright predicted it would "make the Metropolitan [Museum] look like a Protestant barn."

2 FLATIRON BUILDING ▪ **23rd St at Broadway & 5th Ave (Flatiron District, Manhattan)** ▪ Due to its geography and shape, strong winds around the Flatiron Building often blew up women's dresses, inspiring early-20th-century policemen to shoo away would-be oglers with a brisk "23 Skidoo!" Enthusiastically embraced by Manhattanites since its 1902 creation as the Fuller Building, this unusual icon was built as a Renaissance palazzo with Beaux Arts styling on a triangular footprint.

3 ROOSEVELT ISLAND TRAMWAY ▪ **Tram Plaza (60th St & 2nd Ave) to Tramway Plaza (Yorkville, Upper East Side, Manhattan to Roosevelt Island)** ▪ Even at an altitude of only 250 feet, alpine knowledge comes in handy: a Swiss company was hired to build the tram in 1976, and Swiss and French companies have maintained and operated it ever since. From 1909 to 1957, the island in the East River could be reached via a trolley midway across the Queensboro Bridge, which had an elevator to the ground. The F subway line has had a stop here only since 1989, about 100 feet below street level. The island was earlier known as Minnehanonck, Varcken Eylandt, Blackwell's Island, and Welfare Island.

4 WONDER WHEEL ▪ **3059 Denos Vourderis Place (Coney Island, Brooklyn)** ▪ The Wonder Wheel is pictured during its yearly winter recess for maintenance. The eccentric 150-foot-diameter Ferris wheel carries up to 144 passengers. Eight stationary cars are mounted on the rim, while 16 more swing violently over an unusual slide ride on an internal rail. During its construction in 1920, all 18 co-owners joined as workmen to insure safety. It has failed only once—during the infamous blackout of 1977. Operators had to hand-crank the wheel to free trapped passengers.

5 *CHARGING BULL* ▪ **Opposite 26 Broadway at Bowling Green Park (Financial District, Manhattan)** ▪ Arturo Di Modica created *Charging Bull* in 1987 as a sign of the "strength and power of the American people" and placed it—guerrilla style—under a Christmas tree in front of the New York Stock Exchange. The police seized it and towed it to an impound lot, but public outcry induced the city to install it at the north end of Bowling Green Park. People think polishing it may bring them luck: "Passersby have rubbed—to a shiny gleam—its nose, horns, and a part of its anatomy which

separates the bull from the steer," the *New York Times* noted in 2004.

6 PATIENCE ▪ **5th Ave bet 40th & 42nd Sts (Midtown, Manhattan)** ▪ The names have changed over the years for the two lion statues that guard the main branch of the New York Public Library. Edward Clark Potter designed the Tennessee marble beasts, which were dubbed *Leo Astor* and *Leo Lenox* to honor the founders of the library; these later became *Lord Astor* and *Lady Lenox*—though both lions are male. In the 1930s, Mayor Fiorello La Guardia nicknamed them "Patience" (the southern lion) and "Fortitude," after the virtues New Yorkers would need to see themselves through the Great Depression.

7 LIKE A DANCER ▪ **Lincoln Center Plaza, Columbus Ave & Broadway (Lincoln Square, Manhattan)** ▪ A girl with shopping bags rests in front of the Revson Fountain, the centerpiece of Lincoln Center's main plaza. Initiated in the 1950s by a civic consortium led by John D. Rockefeller III, the center's three main buildings are the Metropolitan Opera House, the Avery Fisher Hall (formerly Philharmonic Hall) to the north, and the David H. Koch Theater (formerly the New York State Theater) just to the south. Today Lincoln Center features 29 indoor and outdoor performance facilities and 11 resident arts organizations.

8 LOVE ▪ **SE corner of 6th Ave & W 55th St (Midtown, Manhattan)** ▪ Love exists in so many forms—but it has taken this iconic shape since 1958, when pop artist Robert Indiana created it first in a written poem and later as an oil painting. *LOVE*'s career took off in 1964, when MoMA featured it on a Christmas card; that was followed by a U.S. postage stamp in 1973, countless prints, and, for Valentine's Day 2011, a Doodle for Google. Since 1970, at least 38 authorized COR-TEN steel sculptures have been placed throughout the United States and Canada, Europe, and Asia. The original Indiana can be seen in the Indianapolis Museum of Art, Indianapolis, Indiana.

9 TRANSPARENT TRIPOD ▪ **766 5th Ave, at E 59th St (Midtown, Manhattan)** ▪ Paper wrappings, chewing gum, loose change, and other urban detritus are the assigned prey of this man with a broom. The transparent staircase in Midtown's Apple Store features heavy foot traffic, so he rarely gets a second of rest. The sweeper can mostly be seen performing a complex and rapid choreography around the customers.

10 STUYVESANT TRIPOD ▪ **Stuyvesant Square, 2nd Ave & 16th St (Gramercy, Manhattan)** ▪ Hated and loved in nearly equal measure, Peter Stuyvesant served as the last Dutch Director-General of the colony of New Netherland from 1647 until the British took over in 1664 and renamed New Amsterdam to New York. Among his New York constructions were the wall after which Wall St is named, the canal that would become Broad St, and Broadway. Stuyvesant is interred in the vault of his nearby family chapel, today's St. Mark's Church in-the-Bowery on E 10th St at 2nd Ave. Numerous famous New Yorkers are buried alongside.

11 THE CLOISTERS ▪ **99 Margaret Corbin Drive (Fort Tryon Park, Manhattan)** ▪ Today a branch of the Metropolitan Museum of Art, this is as close as the United States has come to a medieval cloister complex. John D. Rockefeller started in 1917 to buy up an enormous collection of European medieval art. In the mid-1930s, he asked Charles Collens to design a hybrid of new buildings in medieval style and portions of five medieval abbeys of Catalan, Occitan, and French origins. Rockefeller later gave the museum and Fort Tryon Park to the City of New York. As a gift to New Jersey, he bought a good dozen miles of the steep basalt cliffs across the Hudson River, known as the New Jersey Palisades—to preserve a protected, matching view.

12 PROTECTIVE SHIELD ▪ **High Line Park at 28th St (Chelsea, Manhattan)** ▪ Since the abandoned elevated train tracks were converted into a flashy

park in 2009, they have drawn an international tourist crowd and changed the neighborhood from seedy to ritzy. Japanese artist Hyemi Cho had an idea for dealing with the daily packs of tourists peeking into her window right next to the tracks: she painted this friendly self portrait and provided her neighbors and friends with similar protective shields.

13 SCULPTURE IN MET'S ROOF GARDEN ▪ 1000 5th Ave at 82nd St (Museum Mile, Upper East Side, Manhattan) ▪ Each summer since 1998, the Iris and B. Gerald Cantor Roof Garden at the Metropolitan Museum of Art has hosted a single-artist exhibition. The breathtaking views of Central Park and the Manhattan skyline offer a magnificent background for the sculptures. In 2007, Frank Stella explored in *Chinese Pavilion* leaf formations as one of his main architectural themes.

14 SILVERCUP STUDIOS ▪ 42-22 22nd St (Long Island City, Queens) ▪ What's *not* made here? Since 1983, the former bakery building has been used as New York's biggest film and TV studio. Productions include *The Sopranos*, *Sex and the City*, *Mad Men*, *30 Rock*, *Ugly Betty*, *The Michael J. Fox Show*, *Rescue Me*, *Gangs of New York*, *The Devil Wears Prada*, *Highlander*, *Krush Groove*, and many more. And the subway thunders along right above and behind the building.

15 CLEOPATRA'S NEEDLE ▪ Central Park, behind the Met Museum, 944 5th Ave at 82nd St (Museum Mile, Upper East Side, Manhattan) ▪ The obelisk of Thutmose III (15th century BC), was one of a pair installed in Heliopolis to honor the Egyptian sun god Ra. Fourteen centuries later, Augustus Caesar had them transferred to a temple Cleopatra VII built in Alexandria to honor her lover, Julius Caesar. Offered as a gift from Ismail, the Khedive of Egypt, to New York, the obelisk was erected in Central Park in 1881, in a complicated procedure that took more than six months. Also in the 19th century, its mate made it to London, and a third needle from Luxor stands in Paris.

16 GEMINI TITAN II ROCKET ▪ 47-01 111th St (Corona, Queens) ▪ A Gemini Titan II rocket, donated by NASA, stands 103 feet tall in Rocket Park at the New York Hall of Science. The museum was installed in 1964 as part of the World's Fair in Flushing Meadows Corona Park. The rocket was originally built for the Air Force as an intercontinental ballistic missile to carry nuclear warheads, but NASA acquired it to send astronauts into orbit instead. It never took off in the Gemini program though, thus saving $3.16 million per launch, even back in 1969.

17 LENIN ON THE RED SQUARE ▪ 250 E Houston St, seen from Norfolk St (East Village / Lower East Side, Manhattan) ▪ When Michael Rosen, former professor of radical sociology at NYU, developed the Red Square luxury apartments in 1989, he crowned the complex in 1994 with an originally Soviet-commissioned 18-foot statue of Vladimir Ilyich Lenin, which American art dealers had discovered in a dacha near Moscow. Rosen, a controversial figure in the neighborhood, dedicated his time afterward to developing housing for battered women and AIDS victims.

18 MINERVA GREETING LIBERTY ▪ 500 25th St at 5th Ave (Greenwood Heights, Brooklyn) ▪ Minerva, Roman goddess of battle and protector of civilized life, offers a salute from Battle Hill in Green-Wood Cemetery to the Statue of Liberty, which can be seen 3.5 miles to the west on the other side of New York Harbor. The Revolutionary War memorial *Altar to Liberty: Minerva* marks the burial spot of "ink king" Charles M. Higgins. On this hill in late August 1776, about 6,000 Britons defeated 2,000 Americans during the Battle of Long Island. Among Green-Wood's roughly 600,000 interred are hundreds of prominent citizens.

19 WE CAN HANDLE IT ALL! ▪ Times Square at 43rd St (Theater District, Manhattan) ▪ National colors dominate this frame, and the phrase "We Can Handle It All!" is mirrored in the windows of the U.S. Armed Forces

Career Center on Times Square while a police car passes by. If you happen to wear the right uniform and have the looks and ability to connect with people, you might get the quite unusual duty assignment of signing up volunteers for service in the army, navy, marines, air force, and coast guard—right here at the "crossroads of the world." Walk in and ask for their best stories!

20 **INDIVIDUAL TO A POINT** ▪ **30th St bet 1st & 2nd Aves (Kips Bay, Manhattan)** ▪ In 1965, New York received its first exposed concrete buildings. I.M. Pei and S.J. Kessler built Kips Bay Plaza (today Kips Bay Towers) in the brutalist style. Two 20-story slabs with 118 units take up three full city blocks between 2nd and 3rd Aves and E 30th and 33rd Sts; here we see the 30th St façade. Pei wanted to place a huge Picasso sculpture in the garden, a goal he realized some years later between his Silver Towers in Greenwich Village. [See also **102**.]

21 **CROSSING THE MALL** ▪ **Terrace Drive at the Mall (Central Park, Manhattan)** ▪ Late-night joggers make a futuristic appearance in the flickering street lights while they cross the Mall in Central Park over Terrace Drive, near the Bethesda Fountain. To see and be seen is always a part of the game on Manhattan's greenest stage. The Mall is the only purely formal feature—as

"open air hall of reception"—in the otherwise naturalistic original 1857 plan by Frederick Law Olmstead and Calvert Vaux.

22 **9/11 MURAL AT CAFÉ PICK ME UP** ▪ E 9th St at Ave A (East Village, Manhattan)** ▪ Numerous murals throughout the five boroughs commemorate the terror attacks of 9/11 and the loss of nearly 3,000 lives. While some of these have been spray-painted over or fallen into disrepair, most of these murals are well taken care of. This particular mural, on the side of Café Pick Me Up, gets maintenance whenever necessary.

23 **LINCOLN ON HORSEBACK** ▪ **Grand Army Plaza (Prospect Park, Brooklyn)** ▪ On Brooklyn's busiest traffic circle, the Sailors and Soldiers Memorial Arch is home to the only known sculpture of Abraham Lincoln on horseback. He is riding in the western pillar, opposite Ulysses S. Grant. A stairwell in the eastern pillar leads up to an observation deck and a small space that was used as a puppet lending library and puppeteer's performance space. Do not confuse this location with Manhattan's Grand Army Plaza or Manhattan's Sailors and Soldiers Memorial.

24 **SOLOW BUILDING'S RED DISTRACTION** ▪ 9 W 57th St, bet 5th & 6th Aves (Midtown, Manhattan)** ▪ Concave vertical slopes of the north and south façades are an outstanding feature of

the Solow Building, but they also reveal the ugly side walls of the neighboring historic buildings. After numerous complaints, Ivan Chermayeff was commissioned to place a huge building number nine in red steel smack in the middle of the sidewalk to distract the passersby. Thanks to its fantastic views, the 1974 building has long been one of the top rent earners in New York.

25 *REFLECTING ABSENCE* ▪ WTC Memorial (Financial District, Manhattan)** ▪ One of the two pools at the memorial for the attacks on the World Trade Center in 1993 and 2001, created by architects Michael Arad and Peter Walker. On the footprints of the twin towers, *Reflecting Absence* features water falling over an edge with enormous white noise and a sucking feeling. One can't see where the water falls as it simply disappears into a roaring void. [See also **135**.]

26 **THE JAVITS'S CRYSTAL PALACE** ▪ 11th Ave bet 34th & 40th Sts (Hudson Yards / Midtown West, Manhattan)** ▪ The sun shines through the roof of the "Crystal Palace," the lobby of the Jacob K. Javits Convention Center. The revolutionary space-frame structure covers about 1.8 million square feet. It was designed by architect James Ingo Freed of I.M. Pei Partners and opened after six years of construction in 1986 on the waterfront of Manhattan's West Side.

27 **SHROUDED IN SHRUBBERY** ▪ **E 48th St & 1st Ave (NW corner of UN area, Turtle Bay, Manhattan)** ▪ Shrouded in shrubbery, this bronze elephant was a gift from Kenya, Namibia, and Nepal to the United Nations. When unveiled in 1998 in the presence of Secretary General Kofi Annan, discussions flamed up over whether the bull elephant was too well endowed. The Solomonic solution was to plant some bushes to block the view.

28 **LIN ZEXU'S FIRM STANCE** ▪ **Kimlau Square, at Chatham Square, E Broadway & Oliver St (Chinatown, Manhattan)** ▪ A statue of Lin Zexu keeps a watchful eye over Chatham Square/Kimlau Square. The Chinese emperor appointed Lin in 1838 to halt the illegal import of opium by British and other foreign traders, mostly the East India Company. Lin's fierce opposition to the trade—he arrested 1,700 opium dealers and destroyed 2.6 million pounds of opium—is seen as the primary catalyst for the First Opium War of 1839–42. Although Lin eventually failed, he is considered a Chinese national hero and a role model for moral governance.

29 **CALATRAVA'S TUNNEL** ▪ **Tunnel under West St; east entrance at Vesey St, Greenwich St, & W Broadway; west entrance at Brookfield Place (Financial District, Manhattan)** ▪ This beauty almost makes you want to go visit New Jersey: Santiago Calatrava's underground corridor links the World Trade Center PATH Station with the Battery Park City Ferry Terminal and Brookfield Place Pavilion (formerly known as the World Financial Center). The 600-foot-long white marble passage crosses under West St as part of the World Trade Center Transportation Hub.

30 **PEELING UP** ▪ **Gansevoort St to 30th St, mostly just west of 10th Ave (Chelsea, Manhattan)** ▪ A peel-up bench, growing out of the deck, is a signature design feature of the High Line's park furniture. It is made of ipe wood, aka Brazilian walnut, a sustainable hardwood tough as nails that withstands hot summers and cold winters. The aerial greenway built on former elevated train tracks is wildly successful not only with tourists but also for real estate developers, and it has contributed to major demographic and cultural shifts in the area. The number of actual meatpackers in the Meatpacking District has declined from about 200 in its heyday to just a handful.

31 **SAILING IN CENTRAL PARK** ▪ **Central Park, near 5th Ave & E 74th St (Central Park, Manhattan)** ▪ *Conservatory Water* was originally planned as a reflecting pool for a conservatory that was never built, but soon the pool became a paradise for children and sailing enthusiasts, following the example of the Jardin du Luxembourg in Paris. Radio-controlled model boats can be rented from April through October. Members of the Central Park Model Yacht Club race each Saturday morning and share the pool with an unusual seasonal freshwater jellyfish.

32 **MANHATTANHENGE** ▪ **Looking west on 33rd St (Midtown, Manhattan)** ▪ Manhattanhenge—named after the spectacular sunset at Stonehenge in the United Kingdom—happens twice a year. The setting sun aligns with the not quite east-west direction of Manhattan's cross-streets, here seen along 33rd St and the Empire State Building. Cross streets following the Commissioners' Plan of 1811 are laid out in a grid offset 29.0 degrees from true east–west—meaning that Manhattanhenge usually falls around May 28 and on July 12 or July 13—on either side of the summer solstice.

33 **HIGHBRIDGE WATER TOWER** ▪ **Amsterdam Ave at E 174th St (Washington Heights, Manhattan)** ▪ This cast-iron stairwell is not for people with vertigo. Built from 1866 to 1872 by John B. Jervis, the 200-foot Highbridge Water Tower was designed to help deliver enough water pressure for a rapidly expanding Manhattan. The tank on top of the neo-Romanesque granite tower was later vandalized, and the charred remnants were

removed during a reconstruction in 1990. The High Bridge at the foot of the tower predates Brooklyn Bridge by 39 years. In 1842, the Old Croton Aqueduct began carrying water down from Westchester reservoirs around the Croton River to reservoirs in Manhattan, across the Harlem River from the Bronx. The walkway over the bridge, said to have often been used by Edgar Allan Poe, was closed in the 1960s, but is supposed to reopen in 2014. The Romanesque appearance of the masonry aqueduct was destroyed with a steel arch in 1928, when the river span was widened for ships.

34 WILLIAMSBURG BRIDGE ASCENT ▪ **Spanning the East River (Lower East Side, Manhattan to Williamsburg, Brooklyn)** ▪ The pedestrian and bicycle path of the Williamsburg Bridge, rising up from Delancey St on the border of the Lower East Side. This was the longest suspension bridge in the world from its opening in 1903 until 1924. When tenor saxophonist Sonny Rollins took his famed sabbatical in 1959, he ventured to the bridge for his practice routine to rebuild his lungs and to spare a neighboring expectant mother from the sound. Upon his return to the jazz scene in 1962, he named his comeback album *The Bridge*.

35 CONEY ISLAND CYCLONE ▪ **Surf Ave at W 10th St (Coney Island, Brooklyn)** ▪ Charles Lindbergh called the experience of riding the Cyclone "more thrilling than flying." In any case, "Keep moving" seems to be an appropriate motto for the historic wooden roller coaster, which has been rattling along in Coney Island since 1927. Designated a NYC Landmark in 1988 and on the National Register of Historic Landmarks since 1991, the red-and-white ride has inspired several copies and mirror layouts operating in California, Germany, and Japan.

36 RIEGELMANN BOARDWALK ▪ **Along the Atlantic seashore from W 37th St to 14th St (Coney Island to Brighton Beach, Brooklyn)** ▪ About 2.5 miles of "Coney's Fifth Avenue" feature Coney Island's remaining amusement landmarks—Steeplechase Pier, Parachute Jump, Wonder Wheel, Cyclone—as well as the New York Aquarium and the Brooklyn Cyclones' baseball stadium. Last but not least, of course, is the wide Atlantic beach that drew them all here in the first place. The boardwalk ends in Brighton Beach, nicknamed Little Odessa for its largely Russian population. When the boardwalk opened in 1923, Coney Island had already been the city's favorite playground for nearly a century. The Mermaid Parade, first held in 1983, is a relatively new tradition.

37 CHANGE FOR THE WHITNEY ▪ **945 Madison Ave at 75th St (Upper East Side, Manhattan)** ▪ The Whit-ney Museum of American Art has always been on the move. Gertrude Vanderbilt Whitney began promoting 20th-century American art in 1914, but the museum, founded in 1931, has always occupied buildings that turned out to be too small for the ever-growing collection. The 1966 building by Marcel Breuer and Hamilton P. Smith in its distinctively modern style (here, the west window), held on for a long time, but a series of attempted expansions failed. A new building, designed by star architect Renzo Piano and currently under construction in the Meatpacking District, should finally address the problem when it opens in 2015.

38 NATIVE BIRD ▪ **1 Bowling Green, bet Whitehall & State Sts (Financial District, Manhattan)** ▪ A Native American mask stares with a stern expression from Daniel Chester French's *Allegory of the American Continent*. The sculpture stands in front of the Alexander Hamilton U.S. Custom House, which contains, among other institutions, the New York branch of the Smithsonian's National Museum of the American Indian. The 1907 Beaux Arts masterpiece was designed by Cass Gilbert, who also created the nearby Woolworth Building in 1913. The pyramid in the background crowns 26 Broadway, former headquarters of John D. Rockefeller's Standard Oil Company of New Jersey. [See also **56**.]

39 POLES ▪ East River at E 34th St (Kips Bay, Manhattan) ▪ What we see is wood, marble, glass, and steel, but how the shapes blend together! The General Secretariat Building at the United Nations headquarters by Oscar Niemeyer and Le Corbusier, completed in 1952, and the black Trump World Tower, opened in 2001 in "monolithic" old-style Miesian Modernism, are seen between docking poles for the NY Waterway and East River ferries at E 34th St.

40 THE GIST OF MIDTOWN ▪ 5th Ave bet W 49th & W 50th Sts (Midtown, Manhattan) ▪ One of the spires of St. Patrick's Cathedral on 5th Ave can be seen in front of the Olympic Tower—the first mixed-use skyscraper in this area. The concave mirror in front, a temporary installation by Anish Kapoor, reflects the façade of the Maison Française. Together with the British Building it forms the Channel, which leads to Rockefeller Plaza and the GE Building (aka the RCA Building) of Rockefeller Center, New York's Art Deco city-within-the-city.

41 LIGHTHOUSE WITH A LOBBY ▪ Fort Washington Park, under the George Washington Bridge (Washington Heights, Manhattan) ▪ The Little Red Lighthouse, built in 1921 at a modest height of 40 feet, was considered obsolete when the mighty George Washington Bridge above was com-pleted in 1931. But plans to demolish the lighthouse in 1951 were successfully thwarted by a protest mounted in large part by fans of Hildegarde Swift's 1942 classic children's book *The Little Red Lighthouse and the Great Gray Bridge*. The story, illustrated by Lynd Ward, centers on the lighthouse's fear that it is now irrelevant, but the bridge reassures it that it is still needed to help keep river traffic safe.

42 SCUDERIA MoMA ▪ 11 W 53rd St, bet 5th & 6th Aves (Midtown Manhat-tan) ▪ The Museum of Modern Art owns a small but fine automobile collection. This Ferrari 641 Formula 1 racing car hangs on the lobby wall of the Research and Education Center. It made its debut in 1990 and, in the hands of legendary Grand Prix drivers Alain Prost of France and Nigel Mansell of England, won six races and nearly triumphed at the World Championship. The five other cars in MoMA's collection are a 1946 Pinin Farina Cisitalia "202" GT; a 1952 Truck: utility ¼ ton 4×4, aka Jeep; a 1959 Volkswagen Type 1 Sedan, aka Beetle; a 1963 Jaguar E-Type Roadster; and a 1998 Smart Car smart and pulse Coupé.

43 TAKE OFF ▪ Lower Manhattan waterfront in Battery Park (Financial District, Manhattan) ▪ This colossal, aggressive bronze eagle stands nearly 19 feet high, facing the Statue of Liberty and gripping a laurel wreath over a wave. It signifies the act of mourning at the watery grave of the approx-imately 10,000 American soldiers, sailors, marines, coast guardsmen, merchant marines, and airmen who lost their lives in the Atlantic Ocean during World War II. Their names are inscribed on eight huge granite slabs. John F. Kennedy dedicated the East Coast Memorial on May 23, 1963, six months before his assassination.

44 TUDOR TAXI ▪ 42nd St, seen from Tudor Place overpass (Tudor City, Manhattan) ▪ Façades of Tudor City are mirrored in another New York City icon—a yellow cab. This Gotham land-mark features about 3,000 apartments in 12 buildings. What the ads in 1928 didn't tell: the rough neighborhood of "Goat Hill" then consisted mainly of tenements, slums, slaughterhouses, and a power plant—one reason why the buildings face inward and have hardly any river views. Once cleaned up, though, neo-Gothic Tudor City served as the setting for many TV and film productions.

45 STUFF & GUFF ▪ Herald Square, W 34th & W 35th Sts, Broadway & 6th Ave (Midtown West, Manhattan) ▪ The bronze blacksmiths Stuff and Guff (aka Gog and Magog) pretend on the hour to hit the bell with hammers, but the sound actually comes from an internal mallet. The Minerva clock once crowned the two-story New York Herald Building right here at the north

end of Herald Square—built in 1895 by Stanford White and demolished in 1921, three years before the newspaper folded. Now the clock dominates a little park filled with bronze owls—Minerva's sacred creature and a favorite symbol of the newspaper's founder, James Gordon Bennett.

46 A HOME FOR ALL ▪ 490 Riverside Drive at W 120th St (Morningside Heights, Manhattan)

▪ A home for all, even above this statue of St. Peter. "Interdenominational, interracial, and international" is the motto of Riverside Church, known as a stronghold of activism and political debate since its opening in 1930. Notable speakers over the years include Martin Luther King Jr., Bill Clinton, Kofi Annan, Cesar Chavez, Jesse Jackson, Desmond Tutu, Fidel Castro, Arundhati Roy, and Nelson Mandela. At 392 feet, equivalent to a 32-story building, it is the tallest church in the United States, constructed with a steel frame yet quoting the architecture of famous French cathedrals such as Chartres and Laon.

47 THE HOUSE THAT RUTH BUILT 2.0 ▪ 1 E 161st St (Concourse, The Bronx)

▪ Babe Ruth, seen by many as the greatest baseball player ever, is depicted on a lamppost banner in front of the new Yankee Stadium on the former site of Macombs Dam Park in the South Bronx. The $1.5 billion price tag makes this the most expensive baseball stadium ever built. Opened in 2009, it pays homage to its predecessor in many of its design elements. The career of fabled George Herman "Babe" Ruth Jr. is closely tied to the history of Yankee Stadium. "The house that Ruth built" just south of the new complex was the home ballpark of the New York Yankees from 1923 to 2008.

48 TWO BRIDGES ▪ Brooklyn Bridge & Manhattan Bridge, spanning the lower East River (Two Bridges, Manhattan & DUMBO, Brooklyn)

▪ The eastern pillar of the Brooklyn Bridge can be seen though stone pillars on the Manhattan Bridge. The neighborhood on the Manhattan side between them is accordingly called Two Bridges. The opposite side in Brooklyn was once known as Fulton Landing but since its gentrification has become part of a bigger area now called DUMBO, an abbreviation for Down Under the Manhattan Bridge Overpass. The Manhattan Bridge, built in 1909, was the last of the three suspension bridges across the lower East River, following the Brooklyn Bridge (1883) and the Williamsburg Bridge (1903).

49 PEPSI-COLA ▪ East River waterfront at 4630 Center Boulevard (Long Island City, Queens)

▪ In 1936 this Pepsi-Cola sign crowned a bottling plant in Long Island City and was a familiar sight from Manhattan over the East River, just across the southern tip of Roosevelt Island. The neighborhood has changed drastically since then. The giant sign, measuring 60 × 120 feet, now stands restored and landmarked in Gantry Plaza State Park, just in front of a 24-story apartment building. And the tenants enjoy their river views with a big red Pepsi-Cola sign.

50 NIGHT AT THE APOLLO ▪ 253 W 125th St, bet 8th Ave & Adam Clayton Powell Jr. Blvd (Harlem, Manhattan)

▪ Its predecessor, Hurtig & Seamon's New Burlesque Theater, was strictly "whites only," but when the Apollo Theater opened in 1934, toward the end of the Harlem Renaissance, it quickly rose to fame with mostly African American performers. Its sophisticated audiences were often considered among the most challenging in the United States—the famous Amateur Nights even featured an "executioner," a man with a broom who swept performers off stage when they didn't please the audience. Stars such as Ella Fitzgerald, Sarah Vaughan, and James Brown started their careers on these nights.

51 A TALE OF TWO SKYLINES ▪ 49-02 Laurel Hill Blvd (Woodside & Maspeth, Queens)

▪ New York is densely populated, and so are its cemeteries. Around mid-19th century, Manhattan ran out of room to bury their dead. In 1847, a cholera epidemic and a ban on the creation of new burial grounds in Manhattan turned the problem into

a crisis; the solution lay in the outer boroughs. Brooklyn, the Bronx, and Staten Island already had huge cemeteries, but the new Calvary Cemetery in Queens broke all records: it has been the site of some three million interments, the largest number of any U.S. cemetery. The picture shows the mausoleum of the Johnston brothers, respected merchants, now occupied by prince and pauper alike.

52 **A FIRST NAME AND A LAST SHOT** ▪ **Fort Wadsworth (Fort Wadsworth, Staten Island)** ▪ When Giovanni da Verrazano discovered what are today New York Harbor and the Hudson River in 1524, he didn't dare engage directly with the local Lenape natives. He named the site Nouvelle Angoulême to honor his sponsor, King Francis I of France, and moved on. Nevertheless, the Florentine navigator's name lives on at the Verazzano Narrows and its bridge. The last shot of the American Revolutionary War was reportedly fired here against a jeering rebel crowd at Fort Wadsworth on Evacuation Day in 1783—by an incensed British gunner on a Royal Navy warship. His shot fell well short of shore.

53 **STATEN ISLAND FERRY WHITEHALL TERMINAL** ▪ 4 South St at Whitehall St (South Ferry / Financial District, Manhattan) ▪ Seen looking back from the waterfront viewing deck on the rooftop of the Whitehall Terminal. Eight orange vessels of the Staten Island Ferry travel between here and the St. George Terminal in Staten Island around the clock, and since 1997 for free. The terminal was completely renovated in 2005, is partly powered by solar cells, and includes an indoor farmers' market next to the usual retailers. A veritable traffic hub, the terminal connects the ferries with subways, buses, taxis, and bike lanes.

54 **C ROCK** ▪ Harlem River (Spuyten Duyvil, The Bronx / Inwood, Manhattan) ▪ The "C Rock" displays a huge C in Columbia University's varsity colors, blue and white, painted on a 100-foot-high cliff of Fordham gneiss along the Metro North train line on the Bronx shore of the Harlem River. It was painted in 1952 after Robert Prendergast, a medical student and coxswain of the heavyweight crew team, got approval from the Athletic Department and the New York Central Railroad. The 60 × 60-foot sign close to the Spuyten Duyvil train station was painted from boatswain's chairs lowered from the edge of the rock. It is maintained by members of the Columbia University crew team, whose boathouse is located directly opposite. The Harlem River is New York's traditional rowing course.

55 **GRANT'S TOMB** ▪ Riverside Drive & 122nd St (Morningside Heights, Manhattan) ▪ The view between the two red granite sarcophagi that hold the remains of Ulysses S. Grant and Julia Dent Grant, at Grant's Tomb. This mausoleum for the Civil War general and later 18th U.S. president and his wife overlooks the Hudson River. The sarcophagi are modeled on the sarcophagus of Napoleon Bonaparte at Les Invalides in Paris. On his TV show *You Bet Your Life*, Groucho Marx used to ask, "Who is buried in Grant's Tomb?" The correct answer is, "No one"—because the Grants are entombed aboveground.

56 **ROOM WITH A VIEW** ▪ 1 Bowling Green, bet Whitehall & State Sts (Financial District, Manhattan) ▪ The spectacular rotunda of the Alexander Hamilton U.S. Custom House shows the WPA ceiling painting *An Ocean Liner Entering New York Harbor* by Reginald Marsh. On the spot where Fort Amsterdam once stood, the building today houses such diverse institutions as the New York branch of the Smithsonian's National Museum of the American Indian, the Bankruptcy Court for the Southern District of New York, and the National Archives at New York City. Herman Melville, who was born around the corner—and for whom *Moby Dick* was a total economic failure—used to work in the predecessor of the current building as a customs inspector. [See also **38**.]

57 **FORT TOTTEN** ▪ Fort Totten Park, Totten Ave (Willets Point, Bayside, Queens) ▪ The improvements in can-

non building came so rapidly during the Civil War that Fort Totten was rendered useless soon after construction began in 1862. Located on the Willets Point peninsula at Little Neck Bay, it shared the duty with Fort Schuyler in the Bronx of securing the entry into the East River from the Long Island Sound. The U.S. Army never left and used it in the 1950s as regional headquarters for the Nike Project air defense. The City of New York owns Fort Totten today and has turned parts of it into a public park. The police and fire departments have training sites here as well.

58 FADING MEMORIES ▪ 35 City Island Ave & Rochelle St (City Island, The Bronx) ▪ Like fading memories, this WTC mural at the defunct Neptune Inn on City Island has been gnawed at by the teeth of time. This nubbin of the Bronx extending into the Western Long Island Sound evokes memories of small towns in New England and has a great naval history. Several America's Cup yachts were built here; there are four yacht clubs, two sail lofts, and several marinas in business; and on summer weekends the whole island is clogged with visitors who come to eat seafood.

59 WASHINGTON SQUARE ARCH ▪ Washington Square, at 5th Ave & Washington Square North (Greenwich Village, Manhattan) ▪ For the centennial celebration of George Washington's inauguration in 1889, Stanford White made an arch in wood and plaster, modeled after the Arc de Triomphe in Paris. Because of its popularity, it was replaced three years later with a marble version, which features George Washington twice. This place around the Minetta Creek (which runs underground these days) was once farmland for freed slaves, used by the Dutch to create a buffer zone against the natives. From the 1800s on, it was used as an execution site and potter's field. To this day, 20,000 bodies still lie here. From 1826 to 1850, the area served as a military parade ground, but with the improvement of the residential neighborhood, it was eventually turned into a park.

60 ELEPHANT HIGHWAY, WINE CELLAR, AND COOKIE STASH ▪ Brooklyn Bridge, spanning the lower East River (Two Bridges, Manhattan & DUMBO, Brooklyn) ▪ In 1884, a year after the Brooklyn Bridge was completed, P.T. Barnum exploited the fear of an imminent bridge collapse for one of his biggest publicity stunts: he sent his 7-ton, 13-foot-tall star, the African elephant Jumbo, over the bridge, leading a parade of 21 elephants. Since then, people have jumped from it, flown underneath it, and used it to flee from the 9/11 terror attacks. During the Occupy Wall Street movement, more than 700 people were arrested on it. But there are still secret, quiet places: vaults under the bridge, some of them predating the bridge by seven years, were used to store wine and champagne because they provided a constant temperature. The Blue Grotto in one of the arches at the Manhattan end even featured a shrine to the Virgin Mary, brought from the Pol Roger cellars in Épernay, France. In 2006, city inspectors found a bunker from the Cold War era hidden within the masonry anchorage, still containing 352,000 cookies, water, and other emergency supplies, in case of a nuclear attack.

61 NIGHT AT NORTH COVE ▪ North Cove Marina on the Hudson River at Brookfield Place (former World Financial Center) (Battery Park City, Manhattan) ▪ "One need never leave the confines of New York to get all the greenery one wishes—I can't even enjoy a blade of grass unless I know there's a subway handy, or a record store or some other sign that people do not totally *regret* life." An excerpt of Frank O'Hara's "Meditations in an Emergency" was lettered in steel in 1986 on the fence of North Cove Marina, a small yacht harbor along the Hudson River in Battery Park City in Lower Manhattan. The tribute also quotes Walt Whitman's "City of Ships": "City of the world! (for all races are here; / All the lands of the earth make contributions here); / City of the sea! . . . / City of wharves and stores! city of tall

façades of marble and iron! / Proud and passionate city! mettlesome, mad, extravagant city!"

62 FANELLI CAFE ▪ **94 Prince St at Mercer St (SoHo, Manhattan)** ▪ A favorite sport for NYC buffs is to dispute which might be New York's oldest continuously operating drinking establishment. Who's to say who was first? Is it Pete's Tavern (in 1851, a "grocery and grog store," and from 1864 on a proper bar), McSorley's (claimed to be 1854, but probably 1862), or the Ear Inn (a tavern in 1835, and likely a bar even earlier)? In any case, such business started here in 1847—beer and liquor were served in a grocery store, with a bordello in the back. The ground floor of a new building six years later was described as a saloon. Michael Fanelli took over in 1922 and ran it during Prohibition as a speakeasy. About 30 years ago, Hans Noe bought the bar and passed it on to his son, Sasha.

63 SPLIT DECISION ▪ **Lafayette & Mulberry Sts splitting from Bleecker St (NoHo, Manhattan)** ▪ Broadway doesn't create all the triangular plots in Manhattan; NoHo has its own Flatiron lookalike. This little neighborhood just north of Houston St attracted such residents as Robert Rauschenberg and Frank Stella, Cher and Keith Richards. Everyone knows that the area south of Houston St is called SoHo, and wags tired of real estate developers'

constant schemes to make up new marketable neighborhood names duly renamed the median of Houston St itself to MoHo—Middle of Houston.

64 GOTHAM SKY BRIDGE ▪ **Thames St bet Trinity Place & Broadway (Financial District, Manhattan)** ▪ Built in 1905 and 1907, the richly decorated Trinity and U.S. Realty Buildings framing the eastern end of Thames St are 264 feet deep but only 50 feet wide. The near-twin towers (at 21 and 22 stories) are connected via an elegant sky bridge close to Broadway. Francis Kimball chose their neo-Gothic style to match Trinity Church, just south of the neighboring cemetery—the wealthiest congregation of any denomination in New York. No one has ever made more money in Manhattan real estate than Trinity Church, which once owned every single square foot between Fulton and Christopher Sts, Broadway, and the Hudson River.

65 A PALM HOUSE WITHOUT PALMS ▪ **150 Eastern Parkway and 990 Washington Ave (Prospect Park, Brooklyn)** ▪ New York has everything—even a Palm House without palms. The glass and steel structure at Lily Pond Terrace can be rented for weddings and other events. Founded in 1910, the Brooklyn Botanical Garden takes ample pride in displaying more than 10,000 different plants but even more in the fact that you can find all things Japanese here:

a reproduction of Kyoto's Ryoanji Temple with a Zen-style pebble garden, a Japanese hill-and-pond garden in four different styles, and a collection of bonsai trees unequaled on the American continent. The monthlong *hanami* cherry blossom festival of the more than 200 Japanese cherry trees draws thousands of visitors every spring.

66 A PALM HOUSE WITH PALMS ▪ **Winter Garden Atrium at Brookfield Place (former World Financial Center) (Battery Park City, Manhattan)** ▪ The 16 *Washingtonia robusta* palm trees in the Winter Garden Atrium are allowed to stay only until they are about 10 years old. By then they have usually grown from 35 to 60 feet and are about to touch the glass roof of the 10-story domed pavilion (this picture was taken in 2008). The 1988 building was one of the first to be reconstructed after the 9/11 terror attack; new trees and fresh glass panes covering 45,000 square feet were back in place by 2002. In 2013, the latest batch of palms was chopped, chipped, and turned to mulch for use in gardens at local hospitals "to honor their role," owner Brookfield has stated, in making the Winter Garden "both a place to meet and a place to rest."

67 DOUBLE SKYLINE AT NIGHT ▪ **49-02 Laurel Hill Blvd (Woodside & Maspeth, Queens)** ▪ An unusual Manhattan skyline, seen from the Calvary Cemetery

in Queens at the foot of Kosciuzko Bridge on the Brooklyn-Queens Expressway (aka the BQE or I-278). The Johnston brothers' mausoleum dominates the foreground, and the well-known buildings behind it are the Citigroup Center, the postmodern Sony Tower—aka "Chippendale"—and the Royale apartment building.

68 BRICKS, PONZI, & JAZZ ▪ 53rd St bet 3rd Ave & Lexington Ave, seen from 1st Ave (Midtown East, Manhattan) ▪ Old apartment buildings on 1st Ave are remnants of a time when Midtown East wasn't yet so upscale. The Lipstick Building (John Burgee and Philip Johnson, 1986) doesn't house anyone from the cosmetics trade, but once a notorious tenant rented floors 17 to 19 for a mere 24 employees: former NASDAQ chairman Bernard Madoff, who operated a $65 billion Ponzi scheme—the largest in history—from here. Hugh Stubbins's 1977 Citigroup Center in the background stands out in Manhattan's skyline with its 45-degree angled roof. Less known is St. Peter's Church, nestled at the foot of the 59-story tower on Lexington Ave, which sponsors an acclaimed jazz program.

69 SYLVAN TERRACE AT THE MORRIS-JUMEL MANSION ▪ Sylvan Terrace bet St. Nicholas Ave & Jumel Terrace (Washington Heights, Manhattan) ▪ Twenty nearly identical wooden row houses with high stoops,

all dating back to 1882 and in the same color scheme, neatly lined up along a cobblestone street—this you can find only in Washington Heights. At the far end stands the Morris-Jumel Mansion, known as the oldest house in Manhattan, dating back to 1765. George Washington used it as temporary headquarters after losing the Battle of Long Island in 1776, and when he was defeated again less than a month later in the Battle of Harlem Heights, the British took over and used the mansion as their headquarters, too. Don't miss the summer jazz concerts.

70 COMMUNICATION ▪ Manhattan Bridge, seen from Washington St (DUMBO, Brooklyn) ▪ Now a gallery, the brick building on the corner of Washington and Plymouth Sts was once a boiler house, built in 1910 to supply the dozen surrounding industrial buildings of the Gair Company with steam. Nestled between the Brooklyn Bridge and the Manhattan Bridge, the area once known as the Fulton Ferry District dissolved into the bigger, hipper DUMBO (Down Under the Manhattan Bridge Overpass), which stretches out farther east.

71 HOLLOW INTEGRITY ▪ 8 Broad St (Financial District, Manhattan) ▪ The economic engine of the United States is run from a Roman temple known as the New York Stock Exchange. In the 16-foot-high pediment, *Integrity*

Protecting the Works of Man stretches her arms outward with clenched fists, but the impression of strength and stability is deceptive: the heavy marble figures of prosperity started crumbling away within decades of the building's construction in 1903, and they were replaced in 1936 with replicas made of white lead–coated sheet copper—secretly, so that the public wouldn't get funny ideas that any facet of the Stock Exchange could be vulnerable.

72 GREEN-WOOD'S MONK PARROTS ▪ 500 25th St at 5th Ave (Greenwood Heights, Brooklyn) ▪ Green-Wood Cemetery is not just a city of about 600,000 dead but also is home to a quite lively population. In the spires of the impressive neo-Gothic entry gates, built by John Upjohn in 1861, nests a quirky and boisterous flock of monk parrots. There are competing theories about their origins—one of the more probable ones is that a bunch of birds escaped in the 1960s from an Argentinean crate while being handled at John F. Kennedy Airport. Another group lives at the southern tip of City Island in the Bronx, and other populations exist throughout Brooklyn. The Brooklyn Parrot Society offers free safaris.

73 THOMAS CAT ▪ 273 Elizabeth St, bet E Houston & Prince Sts (NoLIta, Manhattan) ▪ Elizabeth St in NoLIta

has changed beyond recognition since Martin Scorsese grew up here. Sure, Old St. Patrick's Cathedral further south is still there, and Moe Albanese, whose father opened the Albanese Meat Market in 1923, is still around. But boutiques with names like Trust Fund Baby hint at who is paying the rent here now. In a former butcher shop right next door and opposite to Moe's red storefront is a tiny gallery called Moe's Meat Market. The charming way they treat their gallery cat in the holiday season didn't go unnoticed.

74 **ART IN THE MAKING** ▪ E 6th St & 2nd Ave (East Village, Manhattan) ▪ Since the mid-1980s Jim "Mosaic Man" Power has been telling the colorful story of the East Village in his legendary Mosaic Trail—in tiles, mostly on lampposts, but also on planters and walls. The Vietnam veteran deems his work therapeutic, and he is always friendly and full of good stories. City workers have often destroyed his work; during Rudy Giuliani's tenure he lost 50 lamppost designs at once. Now Power is allowed to work on 80 lampposts but needs continuous donations to keep going. Invest in a good cause! Friends have helped him with a social media campaign, so he is hard to miss. And, yes, that is the iconic neon sign of Carmine Palermo's Block Drugs pharmacy on the corner.

75 **DOUBLE CLAIM** ▪ Ellis Island, Upper New York Bay (80% New Jersey, 20% New York) ▪ From 1892 until 1954, Ellis Island in the Upper New York Bay was the gateway for millions of immigrants to the United States. A curious argument about the place has even occupied the Supreme Court: both New York and New Jersey claimed Ellis Island and neighboring Liberty Island with the Statue of Liberty. The dispute originated in colonial times, when the islands were deemed New York's exclaves, although the state border runs through the middle of the Hudson and the bay. Things are still complicated—let's shorten it to "mostly shared responsibilities"—but nobody cares on sunny days like these, when pleasure boats like the 80-foot gaff-rigged schooner *Adirondack* sail by.

76 **IAC HEADQUARTERS** ▪ 550 W 18th St, at 11th Ave (Chelsea, Manhattan) ▪ Frank Gehry's first commercial office building in New York looks like something between a sailboat on steroids and an illuminated iceberg. The headquarters of the media and Internet company InterActiveCorp, known as the IAC Building, has 10 floors, though it's difficult to tell when you regard its two stacked levels at a height of 160 feet. Instead of using his signature titanium for an outer skin as originally planned, Gehry followed the mandate of IAC head Barry Diller and went with

glass on this one. Of the 1,437 exterior glass panels, 1,349 are unique in shape and degree of twist.

77 **MARINE & AVIATION TERMINAL** ▪ East River waterfront, E 23rd St & Ave C (Kips Bay, Manhattan) ▪ What looks like the bridge of a ship is in fact a detail of the Marine & Aviation Terminal. There is a gas station and a small port for a fleet of pleasure yachts, and, should you happen to live in style and have a seaplane at hand, you can land it here at the swimming dock of Seaplane Base 6N7—as long as your aircraft has three propeller blades and you don't fly over the 59th St Bridge. Further south, at Stuyvesant Cove Park, are the last remains of the water pipes that once supplied Manhattan, nailed together from wooden planks. The company that built this system still uses to this day a logo with a stylized representation of these pipes. Once known as the Manhattan Company, it's now called JPMorgan Chase.

78 **METLIFE SKY BRIDGE** ▪ E 24th St bet Madison Ave & Park Ave South (Rose Hill / Madison Square, Manhattan) ▪ A sky bridge connects the two buildings of the Metropolitan Life Insurance Company on Madison Square. The older South Building, dating back to 1893, was replaced in 1953–57. Its addition, the 1909 tower, modeled after the Campanile at St. Mark's Square in Venice, held the

record at 700 feet as the world's tallest building until 1913. Unfortunately the rich ornamentation got stripped off in 1964. The Great Depression brought plans to replace the northern annex building with a 100-story tower to a screeching halt. Instead, a beautiful polygonal 32-story tower in Art Deco style was completed in 1950, with 30 elevators and the structural strength for 100 stories. [See also **138**.]

79 **NBC SKY BRIDGES** ▪ **10th Ave bet 15th & 16th Sts (Chelsea, Manhattan)** ▪ Seen from the High Line Park, looking south toward the Statue of Liberty and Ellis Island in New York Harbor, sky bridges connect the former Nabisco Buildings over 10th Ave. Beginning in 1890 at this site, the National Biscuit Company used to bake everything here from Saltines to Oreos (which were invented here in 1912). Today the complex between 9th and 10th Aves is a stylish mall, home to the Chelsea Market, Google, Major League Baseball Productions, and New York's local cable news channel NY1.

80 **FAMOUS PATTERNS** ▪ **Brooklyn Bridge & Manhattan Bridge, lower East River (Manhattan & Brooklyn)** ▪ The strong wire cables of Brooklyn Bridge (in the foreground) and Manhattan Bridge look like silken threads of spider webs. Some numbers? Each of the four steel cables on the Brooklyn Bridge, with a diameter of 15 inches,

consists of 19 strands of wire. These are about as thick as a pencil, and each strand has 287 wires—adding up to 5,434 wires spun together. That is sufficient for a load capacity of 18,700 tons. Depending on the source, between 14,060 and 14,400 miles of wire are woven into Brooklyn Bridge. To put this number into perspective, the earth's circumference around the equator is 24,901 miles.

81 **1 2 3 SUB 7** ▪ **Times Square, 42nd St bet 7th Ave & Broadway (Theater District, Manhattan)** ▪ It's showtime! Even the subway sign on Times Square has to live up to the surrounding glamour and lights of the Great White Way. Plenty of subway lines meet under the "crossroads of the world." As the A train conductor can be heard on crackling speakers: "Connections are available to the C, E, N, Q, R, 1, 2, 3, and 7 trains and duh shuh-ul to Grand Central. Sta-CleoCloDoPle!" For new or non–New Yorkers, "duh shuh-ul" stands for "the shuttle," commuting between Times Square and Grand Central Terminal. "StaCleoCloDoPle!" stands for "Stand clear of the closing doors, please!"

82 **TRANSFER BRIDGE AT GANTRY PARK** ▪ **Gantry Plaza State Park (Hunters Point, Long Island City, Queens)** ▪ This "contained apron" transfer bridge at the East River shore, built in 1925, was used to load and unload rail car floats that served industries on Long Island

via the Long Island Rail Road tracks along 48th Avenue. The northern portion of Gantry Plaza State Park was a former Pepsi bottling plant —now only the huge sign, 60 × 120 feet, is still on display. [See also **49**.]

83 **THE EPITOME OF MARINE LOWER MANHATTAN** ▪ **South Street Seaport to Governors Island (Seaport / Financial District, Manhattan)** ▪ This most compressed view of the Lower Manhattan waterfront leads through the sail rigs of the tall ships *Peking* and *Wavertree* over the docks of Pier 11, which serves a total of 10 ferry lines. Beyond that is the helicopter pad on a pier in the East River. Seen between the masts farther south is a Staten Island Ferry, leaving Whitehall Terminal toward Staten Island, and the view reaches Castle Williams on Governors Island. Together with Fort Jay, the island's other major fortification, Castle Williams dates back to the beginning of the 19th century.

84 **BROOKLYN ARMY TERMINAL** ▪ **2nd Ave bet 58th & 65th Sts (Sunset Park, Brooklyn)** ▪ Brooklyn Army Terminal, the largest supply base for World War II, was built in just 17 months and opened in 1919 as a large complex of warehouses, offices, piers, docks, cranes, rail sidings, and cargo loading equipment on 95 acres. Inside the eight stories of cathedral-sized Building B, under a skylight the size of three football fields,

balconies eased the loading of supplies on and off trains that arrived on two tracks. Between the world wars, the U.S. government stored confiscated liquor from thousands of speakeasies here. During World War II, 56,000 workers sent supplies to troops in North Africa and Europe. By the time it closed as a military facility in 1970, 63 million tons of supplies and three million troops had come through its gates, including Elvis Aaron Presley, embarking to Germany in 1958. Most surprising though, is the architect: Cass Gilbert, who created the highly sculpted and ornamented Woolworth Building in 1913. "But when military functionalism was the order of the day," the *AIA Guide to New York City* notes, "he could be as austere as Gropius."

85 **DANCE TO THE MUSIC!** ▪ **Lafayette Ave at Ashland Place & Flatbush Ave (Fort Greene, Brooklyn)** ▪ A steel-and-glass projecting roof looms over the main entry of the Brooklyn Academy of Music. The cutting-edge performing arts venue started out in 1861, making it America's oldest performing arts center; it has been at its current location since 1908. BAM is known for progressive and avant-garde performances and offers traditional and contemporary dance, theater, music, opera, literature, and film in many variations. In the background is the Mark Morris Dance Center, which serves as the permanent home of the Mark Morris Dance Group and offers rehearsal space for the dance community, outreach programs for local children and area residents, as well as a dance school for students of all ages.

86 **BRICK ARCH AT CITY PIER A** ▪ **20 Battery Place (Robert F. Wagner Jr. Park, Battery Park City, Manhattan)** ▪ A public roof deck on the little Italian restaurant in Robert F. Wagner Jr. Park offers a stunning view under a brick arch onto New York Harbor. A Staten Island Ferry and a sailing schooner cross in front of Governors Island. On the left is City Pier A, also called Liberty Gateway, which is the last surviving historic pier in the city, dating back to 1886. The pier was extended in 1900 and 1919 and is said to be the first World War I memorial on American soil. It stood vacant after 1992 and fell into disrepair. Renovations did not start until 2009 and were still underway at the beginning of 2014.

87 **MUSIC ON THE BALCONY** ▪ **Metropolitan Museum of Art, 1000 5th Ave (Museum Mile / Central Park, Manhattan)** ▪ When the eyes get tired—and they will, here at the Met—it is highly recommended to close them for a while and listen to some contemporary or classical music, let's say a string quartet. But where? Right on the balcony of the neoclassical Great Hall of the Metropolitan Museum of Art, where immense domes, vaulted ceilings, and dramatic arches create the feeling of standing in a Piranesi vision. When? Fridays and Saturdays, 5–8 p.m.

88 **UNDER THE BRIDGE** ▪ **12th Ave, under Riverside Drive Viaduct (Manhattanville / Harlem, Manhattan)** ▪ Turning north from 125th St in West Harlem, passing the tiny (not historic) Cotton Club, the view opens onto an industrial stretch of 12th Ave, which runs here under the steel structure of the Riverside Drive Viaduct, built by F. Stewart Williamson in 1901. The 17-acre area bounded by 12th Ave, Broadway, and 125th and 133rd Sts is slated for the wrecking ball, since Columbia University is building a hotly contested $7 billion campus expansion. The plan includes demolishing all buildings—except three that are deemed historically significant—eliminating the existing light industry and storage warehouses, and relocating tenants from 132 apartments.

89 **MUSKET STAIR BALUSTERS** ▪ **Central Park at 64th St (Central Park, Manhattan)** ▪ Military touches such as drum-shaped lamps and these cast-iron muskets, used as stair balusters, are all over the design of this armory in Central Park, if only as a 1936 addition. When the arsenal was completed in 1851 to store explosives and ammunition to defend New York State, the city center was still far to the south around

Houston St. In 1857, the city bought the building, and soon the zoo populated parts of it with apes, camels, elephants, and lions. Their dead counterparts were stored in another part by the American Museum of Natural History between 1869 and 1877. The unloved building survived several demolition plans from 1899 onward, and since 1924 the Parks and Recreation Department has used it as its headquarters.

90 **DRIVING INTO THE SUNSET** ▪ **60 Chelsea Piers at 20th St & 11th Ave (Hudson River Park / Chelsea, Manhattan)** ▪ The sun sets over New Jersey while golfers drive balls from four levels on the converted Pier 59, a 200-foot-long turf fairway, toward the Hudson River. The large net saves boaters from being hit by errant balls. There are facilities here for bowling, ice hockey, swimming, indoor-wall rock climbing—or simply docking your yacht outside at the open-air bar.

91 **WINTER FOG IN TOMPKINS SQUARE PARK** ▪ **Tompkins Square Park, E 7th to E 10th Sts & Ave A to Ave B (East Village, Manhattan)** ▪ Christmas Eve 2008 was unnaturally warm, so fog rose from the melting snow in a peaceful and quiet Tompkins Square Park. The Temperance Fountain, dating back to 1888, was one of 50 fountains gifted by the wealthy San Francisco dentist, businessman, and temperance crusader Henry D. Cogswell, whose

goal was to build one fountain for every 100 saloons in the United States. Tompkins Square, opened in 1850 on former swampland, is of utmost importance for New York's history: it has always been a magnet and cultural center for immigrants of many nations, and it is also known for sometimes violent protest, from the draft riots of 1857 to the riots in 1988 and 1991 against the shutdown of the park itself.

92 **FOLLOW THE YELLOW BRICK CEILING** ▪ **Bridgemarket, 1st Ave at 59th St, Queensboro Bridge (Yorkville, Upper East Side, Manhattan)** ▪ The Bridgemarket supermarket under the Queensboro Bridge features beautiful ceilings. Architect Rafael Guastavino Moreno (1842–1908) from Valencia pioneered the distinctive Guastavino tile, based on the centuries-old technology of the *boveda catalana*, or Catalan vault. Guastavino got a U.S patent for this technique and designed ceilings in major buildings across the United States and in some of New York's most prominent Beaux Arts landmarks, among them Grand Central Terminal, the U.S. Custom House, the Main Hall on Ellis Island, the City Hall subway station, and even the Cathedral Church St. John the Divine.

93 **BOW OF THE *INTREPID*** ▪ **Pier 86 on the Hudson, West St at 46th St (West Side, Manhattan)** ▪ The USS *Intrepid*, built in 1943, operated mostly in the

Pacific theater, most notably the Battle of Leyte Gulf. Recommissioned in the early 1950s, she served mainly in the Atlantic, but also in the Vietnam War. Her prominent role in battle earned her the nickname "the Fighting I," but her frequent misfortunes and long times in dry dock for repairs had some calling her "the Dry I." In 1982, *Intrepid* became the centerpiece of the Intrepid Sea, Air, and Space Museum. After a renovation in 2006–8 at a cost of $120 million, she was joined at the museum site in 2012 by the Space Shuttle *Enterprise*.

94 **BOW OF THE *PEKING*** ▪ **Pier 15 on the East River, South Street Seaport (Financial District, Manhattan)** ▪ The *Peking* is a former Flying P-Liner of the German shipping company F. Laeisz. The steel-hulled, four-masted barque was built in Hamburg in 1911—one of the last windjammers used in the nitrate and wheat trade on the dangerous passage around Cape Horn, before the Panama Canal opened in 1914. After World War I, she went as reparation to Italy until F. Laeisz bought her back in 1923. In 1932, she was sold to the United Kingdom and moored for use as a children's home and training school. In World War II, *Peking* sailed as HMS *Pekin* in the British Royal Navy. She has been at the South Street Seaport since 1975, but the museum doesn't want to keep her for the long term. Of the 20 P-Liners, some of them the largest sailing vessels ever built, four are still

afloat—three as museum ships, one as a school ship.

95 CHANGING TIMES AT ASTOR PLACE
▪ **Astor Place, 3rd Ave to Broadway & E 9th St to St. Mark's Place (East Village / NoHo, Manhattan)** ▪ The roof of the Astor Place–Cooper Union subway entrance kiosk—built in 1904 and reproduced in 1986—plows through the sight of the "Sculpture for Living" Building. The glass façade mirrors the Wanamaker Building, a former pioneering department store. Astor Place is home to Cooper Union, an engineering, art, and design school that offered free education until 2014; in past years it has hosted such famous speakers as Abraham Lincoln, Mark Twain, and Bill Clinton. The area has undergone an enormous transition in the 2010s: the former Wanamaker Building now serves as headquarters of the AOL/Huffington Post Media Group, Facebook is on the way in, and the IBM Watson Group is about to move into a huge, shiny building right opposite that the local community has nicknamed "the Death Star." Editors of the *Wall Street Journal* got so confused in 2013 that they called the area Midtown South.

96 PEERS & NEIGHBORS—NOUVEL & GEHRY ▪ 11th Ave at W 19th St (Chelsea, Manhattan) ▪ Jean Nouvel and Frank Gehry have built right next to each other in Chelsea, furthering the neighborhood's transformation from a gallery district into an international tourist destination. Nouvel, who has designed many surprising projects since the Arab World Institute in Paris in 1987, is famous for breaking up traditional façades and reinventing the separation of inside and outside. The building at 100 11th Avenue, completed in 2010, consists to the west and south of a curtain wall containing 1,650 unique windows at different angles. Each one makes for a different frame to see the outside, "splitting up and reconstructing this complex landscape," with wide views of the Hudson and of Gehry's famous white construction. A totally different wall of black brick faces east toward the High Line. Only to the north does the building abut without comment against its neighbor—a Juvenile Detention Center. [See also **76**.]

97 WHAT GOES UP COMES DOWN ▪ Bryant Park, bet 5th & 6th Aves & 40th & 42nd Sts (Midtown, Manhattan) ▪ On the northern edge of Bryant Park, the W.C. Grace Building looms over 42nd St with its concave façade. The *AIA Guide to New York City* calls it "flashy" and "a disgrace to the street." It seems to have been as badly received by architecture lovers as the similar Solow Building at 9 W 57th St [see **24**]. Bryant Park these days is not only an office worker's open-air lunchroom but also the location of numerous events such as outdoor movies on summer nights and Manhattan's biggest ice skating rink in winter. Its origins are modest, having started out in 1823 as a potter's field. The New York Crystal Palace stood here for a mere five years before burning down in 1858. In 1911, the New York Public Library's main building replaced the Egyptian-style Croton Reservoir, built here in 1842.

98 A DANDELION AND A CABINET ▪ SW corner of 6th Ave and 55th St (Midtown, Manhattan) ▪ Like a frozen explosion, this dandelion fountain appears in front of the 50-story Burlington House, completed in 1969 in corporate international style. The fountain, like its sibling just steps farther south, is often not in operation—maybe because spray on this windswept corner would drench passersby. Martin Cooper, a Motorola inventor, used a base station atop this building in 1973 to make the world's first handheld cellular phone call in public. In the background looms the postmodern Sony Tower, built by Philip Johnson in 1984 as AT&T Tower. It was aptly nicknamed "Chippendale," because the open pediment is reminiscent of the cabinetry of the late-18th-century London–based designer.

99 UNION SQUARE KIOSK ▪ Union Square, 14th to 17th St, Union Square W & E, Broadway & 4th Ave, Park Ave South (Union Square, Manhattan) ▪ Two characteristic kiosks protect the

entrance to the 14th St–Union Square subway station; this is the one to the southwest. Union Square derives its name from the fact that it lies at what was once the union of the city's two principal thoroughfares, Broadway and the Bowery. The street grid of the Commissioner's Plan of 1811 would have yielded lots too oddly shaped to build on, so instead a square was created. Union Square became the traditional site for political rallies and marches, soon after the fall of Fort Sumter in 1861, when about a quarter of a million people gathered for a patriotic demonstration. Nowadays chess players, Hare Krishna followers, musicians, and skateboarders contribute to the daily hustle and bustle around the park, crowned by an equestrian bronze statue of George Washington. A greenmarket, introduced in 1976, led to the nickname "Onion Square."

100 A SPHERE AND A MISSING PLANET ▪ **Entrance at W 81st St bet Central Park West & Columbus Ave (Upper West Side, Manhattan)** ▪ The Hayden Planetarium is part of the Rose Center for Earth and Space at the American Museum of Natural History. A giant 87-foot sphere houses in the upper half the Hayden Space Theater, which displays "space shows" and an accurate night sky as seen from Earth; in the lower half another fascinating show recreates the first three minutes after the Big Bang. When the planetarium

reopened after a renovation in 2000 with a model of only eight planets, excluding Pluto, a heated controversy started. The director, astrophysicist Neil deGrasse Tyson, argued in an open letter why he would prefer to give up the "ill-defined concept" of "planet" in favor of classifying objects in the solar system into five broader families. In 2006, the International Astronomical Union kicked the far-flung icy rock with its five moons off the planet roster for good. [See also **107**.]

101 *FORCE* ▪ **25th St & Madison Ave (Rose Hill / Madison Square, Manhattan)** ▪ *Force* by Frederick Wellington Ruckstull sits on the right side before the Appellate Courthouse at 25th St and Madison Ave; *Wisdom* sits on the left. James Brown Lord's Beaux Arts building, completed in 1900, is compact yet elegant. Six Corinthian columns on a porch uphold a pediment with elaborate reliefs by Henry Niehaus. The most famous academic sculptors of their time carved the figures along the tops of the façades. Even more surprising is the choice of those depicted: along Madison Ave are aligned Confucius, Peace, and Moses, while along W 25th St we find Zoroaster, Alfred the Great, Lycurgus, Solon, Justice, St. Louis of France, Manu, and Justinian. The full name of the court is "Supreme Court of the State of New York, Appellate Division, First Department"—covering the Bronx and Manhattan. The other

departments are seated in Brooklyn, Albany, and Rochester.

102 SHINING LIGHT IN A SEA OF CONCRETE ▪ **Bleecker St to W Houston St & LaGuardia Place to Mercer St (Greenwich Village, Manhattan)** ▪ I.M. Pei's 1966 University Village—a superblock complex like neighboring Washington Square Village just north of Bleecker St—cuts Greenwich Village apart from SoHo. The 505 LaGuardia Place apartment tower and the Silver Towers I and II for NYU staff and students are executed in brutalist style. Barely softening the view is the *Portrait of Sylvette*, a 36-foot-tall concrete sculpture, cast by Norwegian sculptor Carl Nesjar in 1968—in close cooperation with Pablo Picasso, whose two-foot metal sculpture from 1954 was its inspiration. That year, he had created about 40 artistic depictions of the 20-year-old blond, pig-tailed Sylvette David. Against Picasso's habit, his relationship with the model was strictly platonic. Later she married and moved to England, where she started her own career as a painter. To avoid the stamp of being merely a muse to the famous painter, she signed her work in the first years with her married name, Lydia Corbett. [See also **20**.]

103 TAKE THE 'A' TRAIN ▪ **Broad Channel / Howard Beach (Jamaica Bay, Queens)** ▪ The A train, aka the 8th Ave Express, returns from the Rocka-

ways to the Howard Beach/JFK Airport Station. The bridge spans Jamaica Bay, and some buildings of John F. Kennedy International Airport can be seen behind the train. The train has just passed the Jamaica Bay Wildlife Refuge, home to more than 330 bird species and a wider range of native reptiles, amphibians, and small mammals, as well as more than 60 species of butterflies and one of the largest populations of horseshoe crabs in the Northeast. And let's not forget the eel: In his 2007 book *New York Waters*, Ben Gibberd profiled the father-and-son team of Larry Seaman Sr. and Jr., the last full-time eel fishermen of New York City. Superstorm Sandy swept their house and their business away for good in 2012.

104 MUTED TIMES SQUARE ▪ Broadway & 43rd St (Theater District, Manhattan) ▪ Just a rainy afternoon—the total absence of neon or LED lights mutes the impression of a place that is hardly ever quiet, empty, or dark. The Times Square Tower at the southern end of Times Square is reflected in a puddle at the intersection of Broadway and 43rd St.

105 A DIAMOND AND THREE BULBOUS BOXES ▪ W 47th St & 6th Ave (Midtown, Manhattan) ▪ The diamond shaped streetlight marks the entrance to the Diamond District, the block of W 47th St stretching east to 5th Ave, occupied predominantly by Jewish diamond traders and jewelers. Next to Antwerp in Belgium, this is one of the busiest spots in the global diamond trade. Behind the light looms 1211 Avenue of the Americas, aka the News Corp. Building, aka the Celanese Building, which was completed in 1973 in international style as part of the extension of Rockefeller Center. North of the News Corp. stand the McGraw-Hill Building and the Exxon Building. Architect and critic Norval White condemns them all as "posturing, bulbous boxes built in the 1960s and 1970s, grabbing onto the Rockefeller name [...], but sorry neighbors to their parent buildings." And, by the way, no New Yorker calls 6th Ave "Avenue of the Americas."

106 STACKED BOXES AT THE NEW MUSEUM OF CONTEMPORARY ART ▪ Bowery at Spring St (Bowery, Manhattan) ▪ When these sleek stacked boxes of aluminum mesh arrived in 2007 on the gritty Bowery, they certainly raised some eyebrows. Tokyo-based architects Kazuyo Sejima and Ryue Nishizawa created a feeling of flux, change, and development for the New Museum of Contemporary Art. The Bowery itself is in full flux from seedy to ritzy. In Stuyvesant's 1660s, Manhattan's oldest thoroughfare was still farmland beyond the settlement which ended at Wall St. An elegant boulevard rivaling 5th Ave in the first half of the 1800s, the mile-long stretch has continuously spawned cultural achievements in theater and music, as diverse as the Bowery Theatre, Amato Opera, CBGB's, and the Bowery Poetry Club. A long decline lasted from the Civil War until the 1970s, when the city tried to get rid of Skid Row and the Bowery Bums and allow the street to emerge from the dark years under the Third Ave El, which ran here from 1878 to 1950.

107 A SPHERE WITH A BERESFORD VISION ▪ Entrance at W 81st St bet Central Park West & Columbus Ave (Upper West Side, Manhattan) ▪ At times, the sphere in the Rose Center for Earth and Space at the American Museum of Natural History looks like a pickled egg floating in a jar. The glass façade mirrors to the left the Beresford on W 81st St, a 1929 achievement by Emery Roth that has two outstanding features: it is one of the first apartment buildings with elevators leading right into the apartments instead of into a hallway, and it features three rather than just two towers, unlike the Eldorado and the San Remo, Roth's other luxury apartment buildings on Central Park West. Pale Male, the famous philandering red-tailed hawk, temporarily switched from his main residence at 927 5th Ave in 2005 and spent some nights here. [See also **100**.]

108 COLUMBUS CIRCLE SPHERE ▪ Columbus Circle, at W 59th St, 8th Ave, Broadway, & Central Park West

(Midtown, Manhattan) ▪ The 2007 Time-Warner Towers on Columbus Circle, with 55 floors, a height of 750 feet, and a price tag of $1.8 billion, got mixed reviews. Ada Louise Huxtable described them as "exactly what a New York skyscraper should be—a soaring, shining, glamorous affirmation of the city's reach and power, and its best real architecture in a long time." Nicolai Ouroussoff, on the other hand, saw only "a somewhat generic vertical mall whose interior would look at home in an international airport terminal." Kim Brandell's shiny sphere in front of the Trump International Hotel and Tower has many siblings in New York: Gilmore Clarke's *Unisphere* for the World's Fair 1964 in Flushing Meadows Corona Park; Fritz Koenig's *Große Kugelkaryatide* in Battery Park, which stood for 30 years in the fountain of the World Trade Center Plaza and survived the 9/11 attacks; Lee Lawrie's *Atlas Holding the Heavens* in front of Rockefeller Center; and Arnaldo Pomodoro's *Sphere Within Sphere* at the UN Headquarters are only some of them.

109 PORTHOLES ▪ 88 9th Ave, and 346 W 17th St (Chelsea, Manhattan) ▪ Portholes dominate the façades of these two buildings with a maritime past. New Orleans–based architect Albert C. Ledner developed three buildings in the 1960s for the National Maritime Union, with the headquarters at 7th Ave bet 12th & 13th Sts. The façade of the Curran Building (as seen left) is tilted, to comply with setback requirements of the 1961 zoning laws and was temporarily covered with fake brickface storefronts to match the other buildings on the block. It is being converted into a hotel. The second annex, facing 9th Ave and aptly nicknamed the "Pizza Box," was converted in 2003 into the boutique-style Maritime Hotel.

110 SHOWTIME OVER THE HIGH LINE ▪ 848 Washington St, bet Little W 12th & 13th Sts, straddling High Line Park (Chelsea, Manhattan) ▪ Few luxury boutique hotels could survive after developing a reputation as an exhibitionist hotspot, but the awkwardly named Standard Hotel, High Line, seems to have no problem with it. Now and then a curtain opens up and a nude guest peers down on the tourist crowds passing through High Line Park underneath. The tourists probably don't see a thing, since distractions are plentiful on the elevated park built along the former train tracks.

111 CATHEDRAL OF THRIFT ▪ 1 Hanson Place, bet Ashland & St. Felix Sts (Fort Greene, Brooklyn) ▪ To this day this 37-story tower dominates Brooklyn's skyline. The Williamsburgh Savings Bank Tower was built in 1927–29 as the new bank headquarters, designed by Halsey, McCormack, and Helmer in a modernized Byzantine-Romanesque style. The bank insisted on a Renaissance-style dome on top as their signature, because their old building had one, prompting chief architect Robert Helmer to sourly note, "Dome was required by Bank over our dead protests." The pastiche yielded the expected result: the *AIA Guide to New York City* calls it "New York's most exuberant phallic symbol." Even the 60-ton vault doors in the basement are impressive, but truly stunning are the sheer size and cathedral-like quality of the main banking hall with its three naves, arches, vaulted ceilings, and rich decorations. How lame is it of the current owners to be hawking the tower as a "medical condo" with 15 practices and 200 residences?

112 LOVELACE TAVERN FOUNTAIN ▪ 67 Pearl St & Coentjes Slip (Financial District, Manhattan) ▪ The City Bank Farmers Trust Company Building, erected in 1931, is mirrored on the glass lid of the fountain of the Lovelace Tavern at New Amsterdam's Stadt Huys. When Goldman Sachs was planning in 1979 to build here, archeologists proved that about 300 years earlier New Amsterdam's Lovelace Tavern had stood at this very place. Their search for remnants of the Dutch Stadt Huys, aka City Hall, was in vain, but they found artifacts of the tavern next door, built in 1670 and named after the Englishman Francis Lovelace, who governed the city from 1668 to 1673. From 1697 to 1706, the Lovelace

Tavern even served as temporary city hall before burning down completely.

113 ALWYN COURT ▪ 180 W 58th St at 7th Ave (Midtown, Manhattan) ▪ The era of the great Manhattan mansions was coming to an end around the beginning of the 20th century, but luxury apartment buildings still had some resistance to overcome. Gingerly addressing the slow changes in upscale lifestyle, Alwyn Court was advertised as a "City Home for Those with Houses" and a "House of Select Residences." Completed in 1909, the building by Harde & Short displays perhaps the most richly decorated façade in the city, overwhelmed with terracotta crowns and dragons—in the French Renaissance style of king François I, whose symbol, a crowned salamander, can be seen above the entrance.

114 WITTY CARVINGS ▪ 1047 Amsterdam Ave at W 112th St (Morningside Heights, Manhattan) ▪ Manhattan's skyline, a car crashing over a bridge's edge, a DNA structure, and the birth of a child are among the themes Simon Verity and Jean-Claude Marchionni carved into bases and capitals of columns for their 32 figures on the Portal of Paradise, the main entrance in the western façade of the Cathedral of St. John the Divine. The portal was completed in 1997, but other elements remain short of achievement, making the nickname "St. John the Unfin-

ished" seem apt. The idea of building an enormous Episcopal cathedral to rival the Roman Catholic St. Patrick's in Midtown began circulating in 1887, and the cornerstone was laid 15 years later. With difficulty, a first section was opened in 1911, but an "end-to-end" opening didn't happen until a week before the Pearl Harbor attacks in 1941. The death of an architect, war, underfunding, and a fire just after the terror attacks in 2001 have continued to interrupt the building process.

115 TIMES SQUARE MURAL ▪ Times Square subway station at 42nd St & Broadway (Midtown, Manhattan) ▪ Buck Rogers steps out of a spaceship, looking through the remains of a crumbling 20th-century 42nd Street subway station and onto the city of the future—only a detail is shown here. Comic-book characters and science-fiction references are textbook Roy Liechtenstein, who created the 6 × 53-foot porcelain enamel on steel work in 1994, three years before his death. It took until 2002 for it to be installed, after plans to redevelop Times Square were put on ice and the MTA decided instead to renovate the station. The question is, how many of the daily half a million people commuting along here know what they are looking at.

116 WHY THE STATEN ISLAND FERRY IS ORANGE ▪ Upper New York Bay (between Manhattan & Staten Island)

▪ The Staten Island Ferry makes her way across Upper New York Bay to St. George Terminal on Staten Island. In 1926, the original white color scheme was eliminated in favor of a reddish maroon. For better visibility in fog and snow, this was later changed to municipal orange. The city's flag is a vertical tricolor of blue, white, and orange, charged in the center bar with the municipal seal in blue. The tricolor design is derived from the Flag of Prince William of Oranje-Nassau, the one in use by the Dutch Republic in 1625, the year New Amsterdam was settled on the island of Manhattan. It was also called *oranje-blanje-bleu* or even *ranje-blanje-bleu*. The color orange represents the French Principality of Orange, which Prince William inherited from René of Chalon; the white stripe stands for the struggle for freedom and supremacy; and blue is the signature color of the formerly German Nassau County.

117 41 COOPER SQUARE ▪ 41 Cooper Square, bet E 6th & E 7th Sts and 3rd Ave & Taras Shevchenko Place (East Village, Manhattan) ▪ The nine-story atrium is filled with daylight. Its grand staircase starts at the ground floor and terminates at the fourth. From there on, it's complicated to go anywhere higher or lower. The discontinuity of the staircases in Thomas Mayne's addition to Cooper Union is intended to promote physical activity and increase

meeting opportunities. Beyond that, the new Academic Building offers a futuristic, energy-saving, and all-around smart approach with a surprising architecture, though it hardly fits the neighborhood. Cooper Union wanted—against fierce community opposition—to expand its property to create additional sources of revenue by renting commercial space, for example at another development at 51 Astor Place, just north of the main building. Unfortunately, neither this move nor student protests could preserve the prestigious private college's tradition of offering all of its students full-tuition scholarships.

118 **ROOM WITH A VIEW** ▪ **Broadway bet W 48th & W 49th Sts (Theater District, Manhattan)** ▪ Reflections on Broadway, seen from a hotel window just north of Times Square. This may be the only photo in this book of a location that is not freely accessible to everyone at all times. And it wasn't easy to take, either; I could hardly squeeze the camera out of the window, because it opened just a crack. But I am curious whether you can pinpoint the right location, so here you have it.

119 **CORINTHIAN COLOR RAYS** ▪ **645 1st Ave, bet E 37th & E 38th Sts (Kips Bay, Manhattan)** ▪ Like a spaceship emitting colorful rays of light, the Corinthian sits in front of a typical New York City night sky. Der Scutt

and Michael Schimenti created this 55-story fluted tower with hundreds of bay windows for 863 apartments in 1988. Leaving the standard box far behind, the building recalls such predecessors as the elegant Rockefeller Apartments (1936) at 17 W 54th St between 5th & 6th Aves, as well as Chicago's famous Marina City (1964) and Lake Point Tower (1968).

120 **MERCURY** ▪ **42nd St bet Vanderbilt & Lexington Aves (Midtown, Manhattan)** ▪ Mercury is the Roman god of travel, business, and wealth, but he patronizes other departments as well: eloquence, poetry, communication, divination, transitions and boundaries, luck, mischief, and thieves—and at the very end, he conducts souls to the afterlife. Here accompanied by Minerva and Hercules, Mercury commands the position atop Grand Central Terminal's façade on 42nd St facing Park Avenue. Jules-Félix Coutan, creator of the marble group, never set foot onto American soil. Instead he sent a model from Paris, where he was an academic sculptor—who sneered at Auguste Rodin and the impressionist sculptors who deliberately ventured beyond the limitations of academic art. The massive group—arranged at a length of 60 feet and a height of 50 feet in about 1,000 tons of marble from Bedford, Indiana—was built section by section, layer by layer, from 1911 to

1914 by William Bradley & Son, based in Long Island City.

121 **IRISH HUNGER MEMORIAL** ▪ **North End Avenue & River Terrace at Vesey Street (Battery Park City, Manhattan)** ▪ *An Gorta Mor* in Irish Gaelic—here better known as the Great Irish Famine—killed more than a million people in Ireland between 1845 and 1852. Overlooking the Hudson River, Brian Tolle's cooperative effort with 1100 Architecture is a clever structure: a complete rural Irish landscape is supported on a tunneled base containing bands of imported Kilkenny limestone. Between these bands, texts are carved in frosted glass and backlit, retelling the history of the Great Famine in combination with reports about hunger elsewhere in the world. Construction began in March 2001 in the shadow of the Twin Towers of the World Trade Center, and it was finished in July 2002 despite the aftermath of the 9/11 terror attacks. [See also **128**.]

122 **WALK YOUR HORSES** ▪ **W 138th and W 139th Sts bet Adam Clayton Powell Jr. Boulevard and Frederick Douglass Boulevard (Strivers' Row / Harlem, Manhattan)** ▪ David H. King Jr. had it all mapped out: he would tailor these two blocks of elegant row houses and apartments, constructed in 1891–93, to upper-middle class whites. Distinguished architects such as Stanford White created row

houses in different styles, all with back alleys to discreetly stable horses and receive deliveries. King's speculation failed at a time when white people were leaving Harlem in droves. The beautiful buildings stood empty for years because King's financial backer, Equitable Life Insurance Society, balked at selling to African Americans. Finally, during the course of the Harlem Renaissance, ambitious and successful African Americans gained access and could buy into what is known as Strivers' Row. Among them were such illustrious professionals as composer and pianist Eubie Blake; his peer Fletcher Henderson; architect Vertner Tandy; "Father of the Blues" W.C. Handy; surgeon Dr. Louis T. Wright; heavyweight boxer Harry Wills; comedian Stepin Fetchit; tap dancer, actor, and singer Bill "Bojangles" Robinson; and congressman Adam Clayton Powell Jr.

123 **GOLD COAST** ▪ **795 5th Ave, at E 61st St, and 781 5th Ave (Gold Coast / Upper East Side, Manhattan)** ▪ The silhouette of the Sherry-Netherland tower leaves an impression of this neighborhood's luxury on the southern wall of the Pierre, a luxury hotel at 5th Ave & E 61st St. "A tower fit for a muezzin" quipped the *AIA Guide to New York City*. Though quite different, both buildings were designed by Schultze & Weaver; the Sherry-Netherland in 1927, the Pierre in 1929. Each is home

to a hotel as well as apartments. "Gold Coast" seems to be an apt name for the area: the Sherry-Netherland's 18th-floor penthouse went on the market in 2012 for $95 million—and is still available at this price as of January 2014.

124 **GINKGO-GEHRY** ▪ **8 Spruce St, at Williams & Beekman Sts (Financial District, Manhattan)** ▪ Leaves of a ginkgo tree seem to repeat the shape of Frank Gehry's 2011 apartment tower in Lower Manhattan, originally known as Beekman Tower but now marketed as New York by Gehry. Its 76 stories are distributed among 879 feet, and the fact that all its 898 units are for rent *only* is a rarity in the Financial District. The muscular, twisting façade is a cheering statement against the boxy corporate style that New York real estate developers usually prefer. "The finest skyscraper to rise in New York since Eero Saarinen's CBS building went up 46 years ago," cheered Nicolai Ouroussoff in the *New York Times*. In the *New Yorker* Paul Goldberger compared Gehry's tower to the nearby 1913 Woolworth Building, praising it as "the first thing built downtown since then that actually deserves to stand beside it."

125 **HEARST TRIANGLES** ▪ **951-969 8th Ave, bet W 56th & W 57th Sts (Midtown West, Manhattan)** ▪ Sir Norman Foster made a forceful state-

ment when he conjured up his diagrid framing pattern for the glass façade of the Hearst Tower—provoking a stark contrast to the 1928 shell at its base. When Joseph Urban realized "an eclectic fantasy rooted in his early sensibility as a set designer, mixing fin de siècle Vienna with dashes of Art Deco," as Nicolai Ouroussoff described it in the *New York Times*, he was stopped short by the Depression and the depleted coffers of newspaper mogul William Randolph Hearst. The office building never made it beyond the sixth floor. In 2006, the extension finally opened—as the city's first skyscraper completed after the 9/11 terror attacks, pooling Hearst's numerous publications and communication companies under one roof for the first time.

126 **MARINE MERCHANTS MEMORIAL** ▪ **Pier A in Battery Park (Battery Park, Manhattan)** ▪ Sculptor Marisol Escobar, who lives nearby in TriBeCa, created the American Merchant Mariners' Memorial, which depicts merchant mariners in a sinking lifeboat, one of them reaching down to save a drowning sailor. At low tide, the terrified face of this sailor is clearly visible, while at high tide, only his arm is grasping for help from the water. The scene is loosely based on a photo taken from the conning tower of U-123, a German submarine, after it torpedoed the crude oil tanker SS *Muskogee* on March 22, 1942. The surviving sailors

weren't saved—all died at sea. Since the memorial's dedication in 1991, the Maritime Foundation has held commemorative ceremonies on National Maritime Day to remember all the American merchant mariners who have lost their lives at sea from the Revolutionary War to the present day. In the background are New York Harbor and a view over to the shoreline of New York's Staten Island (left) and the loading docks in New Jersey's Bayonne (right).

127 **PUCK BUILDING** ▪ **Lafayette, E Houston, Mulberry, and Jersey Sts (NoLIta, Manhattan)** ▪ The Puck Building in neo-Romanesque style was built in two sections between 1885 and 1893 by Robert Wagner as the printing facility of J. Ottmann Lithographing Company and *Puck* magazine. It features two gilded statues of William Shakespeare's character Puck from *A Midsummer Night's Dream*, one occupying the northeast corner at Houston and Mulberry Sts, and the other over the main entrance on Lafayette St. After *Puck* ceased publication in 1918, the building was home to the company Superior Printing Ink, numerous independent printing firms, and related services. The odor of printing ink permeated the building for many years, and remainders of the massive machinery still can be seen in the basement, which is today used by a sporting goods store.

128 **IRISH NIGHTSCAPE** ▪ **North End Ave & River Terrace at Vesey St (Battery Park City, Manhattan)** ▪ Brian Tolle's memorial to the Great Irish Famine—a period of mass starvation, disease, and emigration between 1845 and 1852 that caused more than one million deaths—carries a complete rural Irish landscape on its back. As a reminder of the ones left behind, the slanted landscape contains stones from each of Ireland's 32 counties. Visitors walk up through a modern tunnel and an authentic stone cottage and ascend along stone walls, fallow potato fields, and the flora of the Connacht wetlands to the top of the memorial, where they can see the Statue of Liberty and Ellis Island in the distance. The cottage is a carefully reconstructed original 19th-century building, donated by Tolle's extended family, the Slacks of Attymass, County Mayo, Ireland. [See also **121**.]

129 **STACKED** ▪ **Brooklyn Heights Promenade & Brooklyn-Queens Expressway (Brooklyn)** ▪ The ever busy Brooklyn-Queens Expressway (aka I-278, or simply the BQE) is stacked atop itself as it conveys traffic along the East River. The Brooklyn Heights Promenade above offers stunning vistas of the Statue of Liberty, Ellis Island, Governors Island, Lower Manhattan, the Brooklyn Bridge, and the Manhattan Bridge. The promenade crowns a bluff, sharply rising from the river's edge, which the native Lenape named Ihpetonga, "the high sandy bank." Brooklyn Heights is a historic and neatly kept neighborhood. In the mid-1950s, a new generation of property owners began moving into the area, pioneering the so-called Brownstone Revival by buying and renovating many of the more than 600 pre–Civil War houses, a unique concentration in the United States.

130 **TRINITY TRIO** ▪ **79 Broadway, at Wall St; 14 Wall St, at Nassau St; 40 Wall St, at William St (Financial District, Manhattan)** ▪ Power Houses in the Financial District: the spire of Trinity Church, once Manhattan's biggest landowner; the pyramid of the Bankers Trust Company Building, once called the world's tallest structure (at 540 feet) on the smallest plot (94 × 97 feet); and the tower of the Trump Building, formerly the Bank of the Manhattan Company Building. The latter was hit in one of three accidental plane collisions with Manhattan skyscrapers: on May 20, 1946, a U.S. Air Force C-45 Beechcraft airplane hit the building in dense fog on its way from Louisiana to Newark. It ripped a 10-foot hole into the 58th floor, and all five aboard died. The first crash happened on July 28, 1945, when 14 people died after an Army B-25 bomber struck the 78th floor of the Empire State Building for the same reasons: dense fog and poor visibility. The last such collision

occurred on October 11, 2006, when New York Yankee pitcher Cory Lidle and his certified flight instructor Taylor Stranger crashed Lidle's Cirrus S20 into the 30th floor of the 50-story Belaire Apartments on 72nd St at the East River waterfront; both died in the crash, which also injured 21 people.

131 RECORDS & EXHAUSTS ▪ **Vanderbilt Ave bet E 43rd & E 44th Sts, and 505 Lexington Ave at E 42nd St (Midtown, Manhattan)** ▪ The exhaust pipes on the outside of the MetLife Building, where it links with Grand Central Terminal, look more like truck parts than an architectural feature. The Chrysler Building, one block farther east on Lexington Ave, picks up the automotive theme with its famed 185-foot Art Deco crown, which architect William Van Alen modeled after a car's radiator grille. When the crown was hoisted into place in a mere 90 minutes in 1930, the Chrysler Building surpassed 40 Wall St [see **130**] and the Eiffel Tower as the tallest structure worldwide, delivering a 1,046-foot surprise in the skyscraper race of the 1930s. The record fell a mere 11 months later when the Empire State Building was completed at a height of 1,250 feet.

132 _PALLAS ATHENE_ ▪ **Columbia University Main Campus bet Broadway & Amsterdam Ave & W 114th & W 120th Sts (Morningside Heights, Manhattan)** ▪ _Pallas Athene_ fits well into the neoclassical foyer of the Low Memorial Library, centerpiece of the Columbia University campus. Like her Roman counterpart Minerva, she is the goddess of wisdom, courage, inspiration, civilization, law and justice, just warfare, mathematics, strength, strategy, the arts, crafts, and skill. Jonathan Ackerman Coles had the marble bust modeled after the _Minerve du Collier_ at the Louvre. The neoclassical library building was designed in 1895 by McKim, Mead, and White—like so much of the Morningside Heights campus—and brims over with Greek and Roman classical references.

133 THE _ALAMO_ ▪ **Astor Place at 3rd Ave & E 8th St (East Village / NoHo, Manhattan)** ▪ The black sculpture across from the Astor Place subway entrance is constructed of about 1,800 pounds of COR-TEN steel, and though it can hardly be turned around its vertical axis by a single person, two can accomplish that easily. Tony Rosenthal planted his sculpture on Astor Place in 1967, saying that it was important to him "that the sculpture interact with the public." And so it does: over the years, people have disguised it as a Rubik's Cube, decorated it with magnetic LED lights, drawn on it with chalk, and dropped magnetic letters onto it. In 2011, street artist Olek—who is known to embellish the neighborhood with her camouflage crochets—pulled a customized crochet cover over the sculpture. The 2013 fake documentary _Man in a Cube_, which went viral, shows a writer named David living in the _Alamo_.

134 HERALD SQUARE VISTA ▪ **Herald Square (Midtown, Manhattan)** ▪ The Empire State Building, framed by older buildings on W 34th St, can be seen from Herald Square. Everyone knows the spire, but the structural body of the building is worth a view as well: a beautiful Art Deco framework is wrapped around the windows, grouping columns using a matching color scheme. The window frames are painted in red and—a rarity for skyscrapers these days—can be opened. The 1930 design by Shreve, Lamb, & Harmon was completed in less than 15 months, but since construction began at the same time as the Depression, it had a hard time finding enough tenants. Mocked as the "Empty State Building" for years, it didn't start turning a profit until 1950.

135 WHITE LINES ▪ **WTC Memorial (Financial District, Manhattan)** ▪ Intersecting white lines are shaped by water falling into one of the two pools at the memorial for the attacks on the World Trade Center in 1993 and 2001. Architects Michael Arad and Peter Walker created _Reflecting Absence_ on the footprints of the twin towers. The roaring of the waterfalls creates a deafening but calming sound and helps visitors block out reality for a

moment to explore their own memories and reflections. [See also **25**.]

136 NIGHT PRACTICE AT THE NEW YORK TRAPEZE SCHOOL ▪ 353 West St, Hudson River waterfront, Hudson River Park Pier 40 (Hudson Square / Greenwich Village, Manhattan) ▪ Why not learn to fly? After starting in upstate New York, in 2002 the New York Trapeze School found this perfect urban foothold along the Hudson, and since then it has ventured into four more locations—in Midtown, Baltimore, Boston, and Santa Monica. Pier 40, anchored on more than 14 acres of landfill, is also home to soccer fields, boating organizations, the New York Knights rugby team, and the offices of the Hudson River Park Trust, which invited the Trapeze School to set up its rig right on the roof.

137 KOREATOWN & MANHATTAN MALL SKY BRIDGE ▪ W 32nd St bet 5th & 6th Aves (Koreatown / Midtown, Manhattan) ▪ A view along "Korea Way" on 32nd St between 5th Ave and Broadway. Koreatown is an unplanned but thriving ethnic Korean business and residential enclave with a multitude of Korean restaurants. The block beyond Broadway, between 6th & 7th Aves, is spanned by an exceptional, multistoried sky bridge, with Manhattan Mall on the north side. The copper-clad sky bridge in Art Deco style was built in 1925 by Shreve, Lamb,

& Harmon, who also planned another real stunner nearby, completed just six years later: the Empire State Building. In the background, Madison Square Garden with the underground Penn Station blocks the view.

138 METLIFE CLOCKS ▪ E 24th St & Madison Ave (Rose Hill / Madison Square, Manhattan) ▪ The wall clocks in the Metropolitan Life Insurance Company Tower are each three stories high, stretching from the 25th to the 27th floors (the west and south sides are visible here). The clock faces, one on each side of the tower, measure 26.5 feet in diameter. The numbers are four feet tall, and each of the minute hands weighs half a ton. When the tower underwent a serious renovation in 1964, the Tuckahoe marble façade material was replaced with plain limestone. Much of the tower's Renaissance-style decoration was removed in 1964 in an ill-advised attempt to "streamline" the tower's design. [See also **78**.]

139 JOHN ST ▪ John St at East River waterfront (Financial District, Manhattan) ▪ The view from Brooklyn, straight across the East River into John Street and thus right into the thicket of Lower Manhattan's Financial District. The masts of the museum ships *Wavertree* (in white, on the left) and *Peking* invoke a time when they were the tallest structures here.

Once, hundreds of sail ships berthed at the numerous Manhattan piers. Even after the time of the windjammers, Manhattan kept a working waterfront. It is estimated that in 1948 the Mafia was in full control of all 906 piers in the Port of New York. The Waterfront Commission of New Jersey and New York started in 1953 to work against the Gambino family on the Manhattan shoreline and the Genovese family on the west side of the Hudson—one year before Marlon Brando starred in *On the Waterfront*.

140 SMALLPOX AND BIG BRIDGE ▪ Southern part of Roosevelt Island (East River, Manhattan) ▪ This 2008 picture preserves an impression of Roosevelt Island before the 25-year renovation of the Queensboro Bridge (in the background) was completed in 2012, and before Louis Kahn's Four Freedoms Park honoring Franklin D. Roosevelt opened at the southern tip in 2012. The foreground shows the ruins of the Smallpox Hospital, which opened in 1856 and closed a century later to become New York's only ruin with a landmark designation. It was built by James Renwick Jr. in 1854–56. Some of his better-known buildings are Grace Church (1843–46), the Smithsonian Institution Building in Washington, DC (1847–55), St. Patrick's Cathedral (1858–79), and Corcoran Gallery (now Renwick Gallery) in Washington, DC (1859–71).

141 **A VERY PRIVATE SPACE** ▪ E 20th St (Gramercy Park South) to E 21st St (Gramercy Park North) & Gramercy Park West to Gramercy Park East (Gramercy, Manhattan) ▪ Access to Gramercy Park, the only private park in NYC, is granted only to people who reside around it and pay an annual fee. It is nestled between Park Ave and 3rd Ave. Irving Place ends at its southern edge; Lexington Ave starts at the northern edge—offering a view of the Chrysler Building. The statue shows Hamlet as played by actor Edwin Booth, founder of the Player's Club on Gramercy Park South and brother of Lincoln's assassin. The neighboring clubhouse here is the National Arts Club.

142 **A VERY PUBLIC SPACE** ▪ Belvedere Castle (Central Park, Manhattan) ▪ Wherever the weather forecasts for New York are broadcast—this is where the city's meteorological pulse is taken. The automated weather station, on site since 1919, is housed in and just beyond Belvedere Castle. The Victorian folly was developed by park designers Frederick Law Olmsted and Calvert Vaux as a Gothic and Romanesque hybrid and built in 1869 of Manhattan schist, quarried right in the park. It sits on top of Vista Rock, the second-highest elevation in the park, overlooking the Great Lawn, the Turtle Pond, and the Delacorte Theater, where New Yorkers have enjoyed free productions by the Public Theater each summer since 1962—mostly Shakespeare, but also other classical works and musicals. In the background looms Emery Roth's San Remo apartment building.

143 **ELEPHANT'S MARCH** ▪ Queens Midtown Tunnel, exits at E 37th & E 34th Sts (Midtown, Manhattan) ▪ How does an elephant get to Madison Square Garden? He takes the Midtown Tunnel! Until 2012, the Ringling Bros. and Barnum & Bailey Circus performed once a year in Manhattan. One of the circus's trains stopped at night in Queens and unloaded a herd of elephants. Off they went, marching through the Queens-Midtown Tunnel and surfacing in Manhattan, here seen from 2nd Ave. Then their march continued at remarkable speed along 34th St across the island. This happened by night to spare the elephants Midtown's daytime stress—but the spectacle still drew up to 20,000 spectators. The tradition was interrupted for a 2011–13 renovation of Madison Square Garden. For now, the circus performs in Brooklyn—since the opening of Barclays Center in 2012—and no decision has yet been made about a return to Manhattan.

144 **KATZ'S DELICATESSEN** ▪ 205 E Houston St & Ludlow St (Lower East Side, Manhattan) ▪ Going strong since 1888, the kosher-style delicatessen is one of the few holdouts on the gentrified Lower East Side—still being praised as one of the best spots to pig out on pastrami or corned beef. Here is far more to experience than regular reenactments of a certain scene from *When Harry met Sally* by Katz's patrons. During the years 1946–49, Katz's expanded along Ludlow St to the corner of E Houston St. Harry Tarowsky, one of the owners, commissioned a new sign, and sign maker George Taran was either hard of hearing or had a funny bone. Asked what should be on the sign, Harry Tarowsky's answer came in thick Yiddish: "Eh—Katz's. That's all!" And that's exactly what he got.

Acknowledgments

For Kate. Without you, here would be nothing. Not even me. You are involved right, left, and center in this book, as you are in my life. So in the end, this is all your fault.

A big thank you goes to my friend James Graff for being James Graff and then some, like improving my language skills and scrutinizing my writing with eagle eyes. Thanks to Roxie Munro and Bo Zaunders for their continued valuable advice, support, great ideas, and contributions. I am grateful to Paul Harrington and the whole team at CN Times Books for their inspiring, smooth, and professional way of making the creation of this book an exciting and rewarding experience. Thanks to my parents for setting me on the right track, and to Bruce L. Kubert for his help with getting started.

About the Author

Janko Puls, born in 1967 in Aachen, Germany, is a photographer and journalist. Since 2006, he has lived with his wife, Kate, in New York City. Janko took degrees in Journalism, Art History, and History of the Middle Ages at Freie Universität Berlin and studied Italian in Perugia, Italy. In 2000, he was invited to Frankfurt to develop the online edition of the national daily newspaper *Frankfurter Rundschau* as managing editor. Besides the development of content, layout, and functionality of the website, he introduced the broader online use of photography in different formats. Upon moving to the United States, he decided to make his lifelong love for photography his profession.

Find out more about this book and see additional photos at www.pointofviewnyc.com, and learn more about Janko at www.jankopuls.com.